THE ARTIST AND THE CAMERA

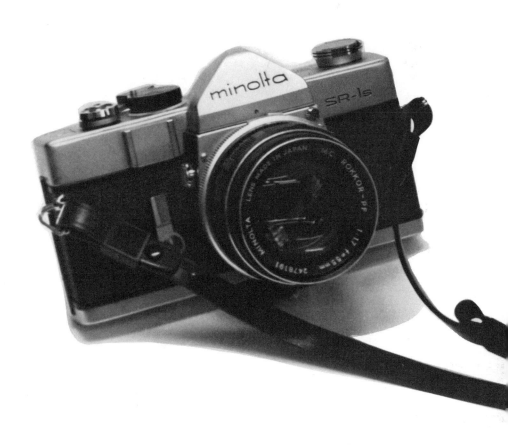

THE ARTIST AND THE CAMERA

By ALBERT MICHINI

PUBLISHED BY NORTH LIGHT PUBLISHERS / WESTPORT, CONN.

To my late wife, Veronica, who encouraged
me through the early, difficult years and
to my present wife, Claire, without
whose help this book could never have
been written.

Published by NORTH LIGHT PUBLISHERS, a division of
FLETCHER ART SERVICES, INC., 37 Franklin Street,
Westport, Conn. 06880.

Manufactured in U.S.A.
First Printing 1976

Library of Congress Cataloging in Publication Data

Michini, Albert.
 The artist and the camera.

 1. Art and photography. 2. Painting from photographs.
I. Title.
N72.P5M5 751 76-40112
ISBN 0-89134-007-6

Edited by Walt Reed
Designed by Albert Michini
Composed in ten point Oracle by Immediate Press Inc.
Color printing by Connecticut Printers, Inc.
Black and white printing and binding
by Haddon Craftsmen, Inc.

CONTENTS

INTRODUCTION

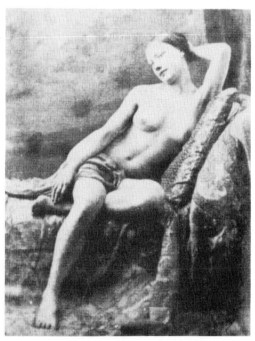

Source photograph from album of Delacroix.

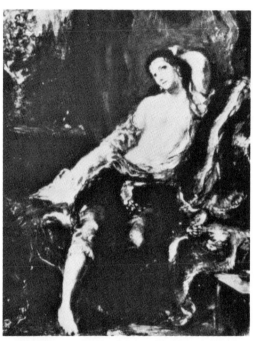

DELACROIX. *Odalisque.* Niarchos Collection.

Painting has undergone some revolutionary changes since the discovery of the photographic process. Admittedly, the advent of the photograph cannot be considered to be the only reason for all the changes. However, prior to photography a great part of the artist's preoccupation was involved with being a human camera. Subsequently, as the superior ability of the camera to record information accurately was accepted, the artist had a new freedom to depart from literal realism -- especially important, he had a new tool to work with.

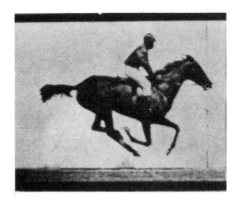

Many artists in the dawn of the photographic era saw the camera for what it could be: an aid like any of the other devices that had long been used, such as the pantograph, the grid and the camera obscura. Thomas Eakins saw in the camera the opportunity to study the figure in motion. He worked with Eadweard Muybridge, a photographer who devoted much of his life to the study of people and animals in motion. It was he who proved a long standing argument that all four feet of the galloping horse leave the ground at the same time during the course of the action. Paul Cezanne worked from photographs and so, too, did Delacroix, Degas and Gauguin. It must be remembered, however, that these great men didn't make duplicates of the photo, but rather used them as a reference source just as they would have used the real subject.

In spite of some public misconceptions about art and photography, it's usually not the intention of the artist when working from a photograph to make his painting an imitation or a reproduction of it. The case

These photographs are from *The Human Figure in Motion* by Eadweard Muybridge.

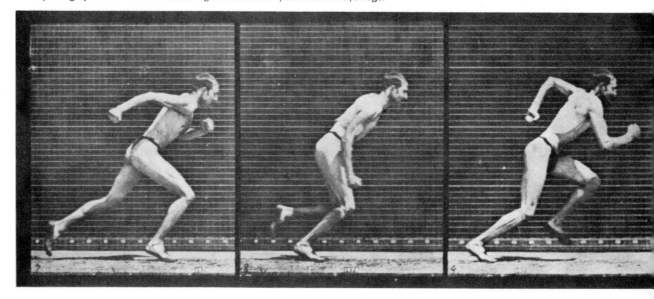

of the New Realists painters might be considered an exception in favor of that misconception, but creating the appearance of reality has little to do with whether the reference source was observed directly or by means of a photograph. Although much of my work reproduced in this text will appear photographic and realistic, it should be apparent that my intentions are like those of every other artist who strives for a personal interpretation of the subject.

As a professional illustrator I'm required to paint Summer scenes in Winter, Spring in Fall, in addition to depicting places remote from my home in Connecticut. It has become absolutely essential for me to work from photos. But I'm not unique. Most artists today have limited time at their disposal, particularly illustrators who work against publication deadlines. Photography is, therefore, a means of accomplishing as much as possible in the shortest amount of time. The camera permits the artist to gain many impressions of his subject in much less time than it takes to make one sketch.

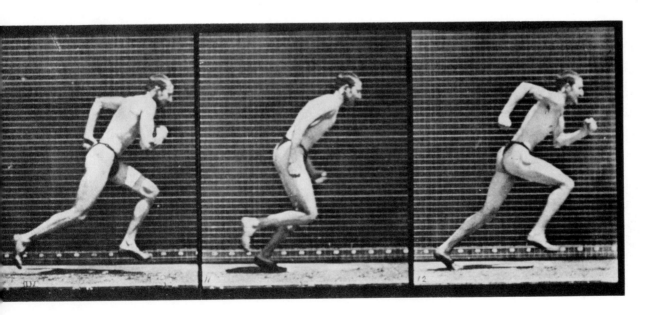

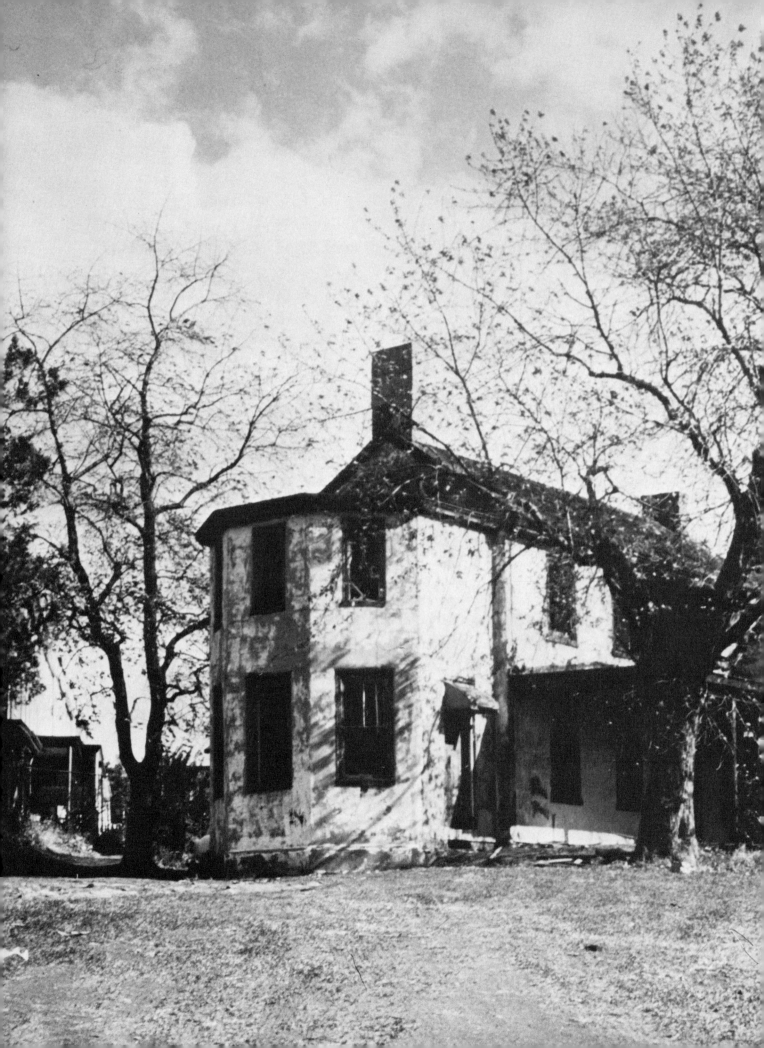

The camera also teaches the artist to see. Leonardo Da Vinci said, "To see is to KNOW." When I was teaching at the Hussian School of Art in Philadelphia, I once planned a three session assignment for my class to demonstrate how the camera can teach the artist to see. The subject for this assignment was an attractive old mansion in a severe state of disrepair. At the first session the students were required to do an on-the-spot study of it. Upon arrival, the 25 students, without exception, were immediately attracted to the crumbling facade of the old building, as I had been in the Spring when I discovered it. Unanimously, they sat down where they were to record it. Although the resulting student impressions varied widely in technique, they were quite similar in substance. This first session lasted three and a half hours.

The second session was an abbreviated one; it lasted for just one hour. This time the students brought their cameras – a twin lens reflex camera was a requirement for the course – with the stipulation that each student must take at least twelve pictures, one roll. To do this successfully they had to look beyond the building's facade to record its true character, both inside and out. Several included fellow students in their photos for scale and possible future situations.

For the last session, which again lasted the full three and a half hours, the students made a painting using one or more of the twelve photos to give a personal interpretation of the old structure. No two were alike. From these sessions the student learned the value of in-depth study to gain a lasting personal impression. This study was facilitated by the ability of the camera to record objectively a great amount of information in a short time.

To prove the effectiveness of these reference photos I gave a set of twelve to each of another group of students who had been at the building, but had not taken photos. All the students were given the same twelve photos. In their initial encounter with the old building these students had reacted the same way as the original group. Although the entire class worked from the same group of photos, no two paintings were alike either in substance or in technique. The students were all able to gain, through their initial contact and the photos, an impression of the old building that was a truly personal one, even though the second group had learned to see without participating in the photo taking.

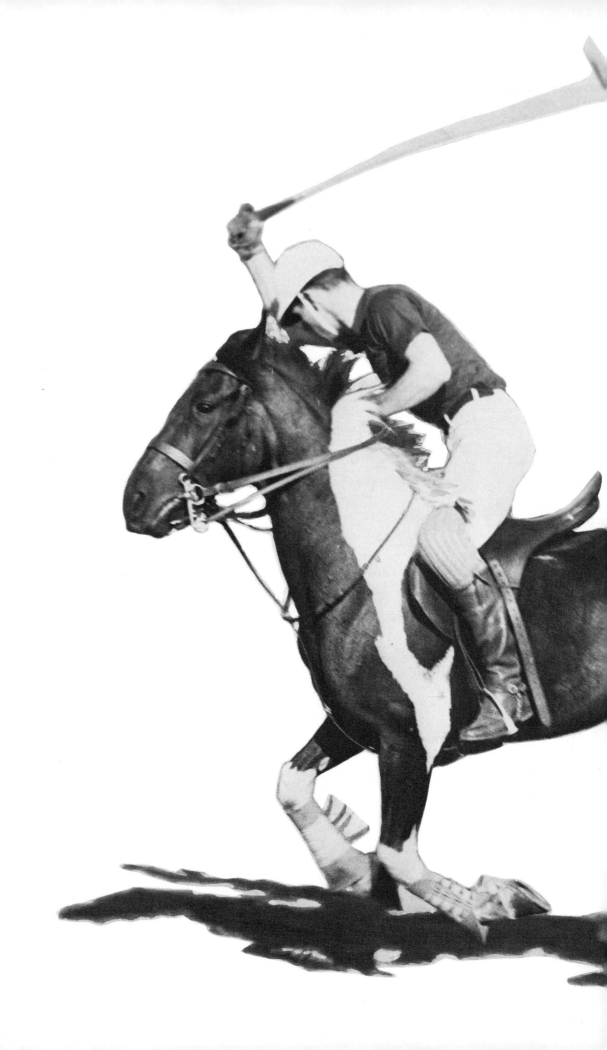

CHAPTER 1

THE CAMERA AS A TOOL

There's no doubt that the ability to record an instant in time is the most fantastic quality of the photograph. To hold back the crashing of a wave on a beach, or the flight of a bird, or capture the glint of sunlight flashing off a farmhouse window, or to prove beyond question that all four feet of a galloping horse do leave the ground at the same time in the course of the action, gives the artist a new dimension in seeing. He is no longer restricted to the quick pencil or a fantastic memory.

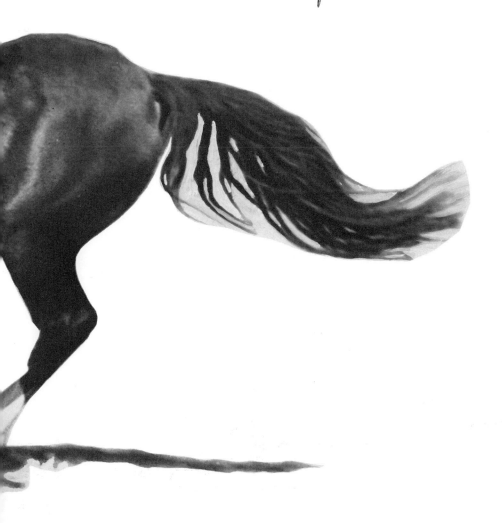

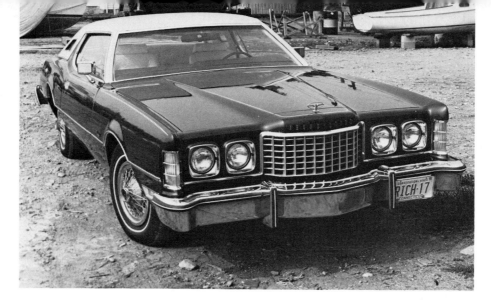

Above. Close-up with the 50mm lens creates distortions such as the over-wide hood and large front wheel. The car also appears to be on a slope.

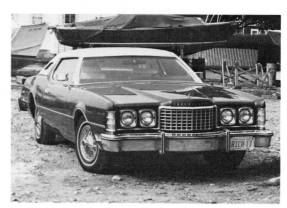

From further away, with the same lens, the hood and wheel appear normal. Note that the ground appears level and the left front tire is now visible.

However, to learn how to make use of the subjects in a photograph, the artist must not see them as the real objects, but as reproductions with shortcomings and distortions. There are certain physical distortions which occur in photographs, due to the camera's single eye. With it, the camera does not see the subject in the same way that you do with two. Objects close to the camera will appear extremely large compared to their surroundings. Try this. Shut one eye. Move your hand toward you and then away from you. Notice that the hand dramatically changes in size. With both eyes open now do the same thing. The hand will not appear to change as much.

This kind of distortion in one-eyed vision is very obvious when you're very close, but it also exists to a lesser degree no matter how far away from the subject you are. Here's an example: in the top photo of a car in which you can see the front and one side, I got as close as I could to fill the viewfinder. Notice that the front wheel is quite a bit larger than the back wheel. In addition, the hood appears overlarge and twisted. The car also appears to be parked on a grade whereas the ground was level. By backing up twenty feet or so, the car appears almost normal in the second photo.

There's another kind of distortion which occurs when the camera is very close to the object. We'll call this eyelevel distortion. Unlike the human eye, which can cover a wide angle view yet be aware of a single focal center, the narrower angle view of the camera sees everything in the area of focus equally well. For example, sit at a table. Look straight ahead. You are aware of the table but see the wall beyond as the focal center. To make the table the focal center you must look down at it. You have two visual impressions. Although the angle of view of the normal camera lens – see pages 86 and 87 – is narrower than the human eye it, too, will see the wall and the

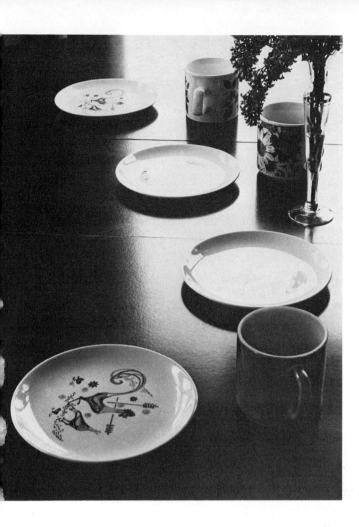

Left, close-up with 50mm lens produces a very round and large dish and cup in the foreground.

Below. By moving further away, with the same lens, the relationships are more natural.

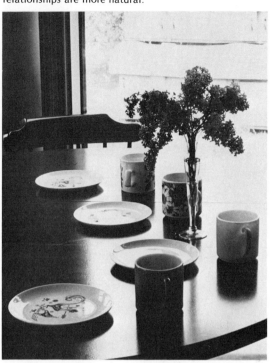

table top equally well but in a single impression. The distortions might be more apparent than obvious. In the larger photo, above, the nearest plate and cup appear over-round and in the smaller photo, which was taken at a greater distance, they appear more natural.

In the photo of my daughter, Suzanne, her head appears overlarge while her legs, which are actually very long, appear short. The most obvious distortion occurs at her feet. She appears to be standing on her toes because we can see the entire top of her sneakers. If you trace the photo, reducing it to a mere outline, it's even more obvious. Were I to take a photo from further away, the above problems would be eliminated.

These distortions are not serious shortcomings, and the artist can easily learn to avoid them. It is in the area of taking pictures that the artist is faced with the major concern of picture quality -- sharpness, exposure, framing, light source and processing.

Close-up with 50mm lens at eye-level produces a larger than normal head, shorter legs. The model appears to be standing on her toes.

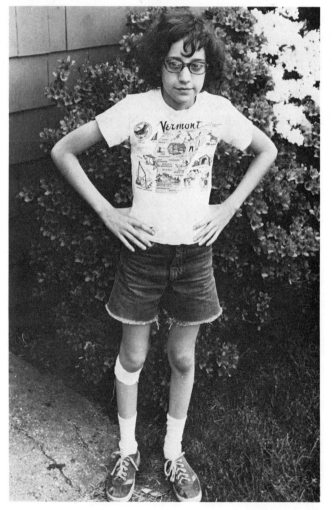

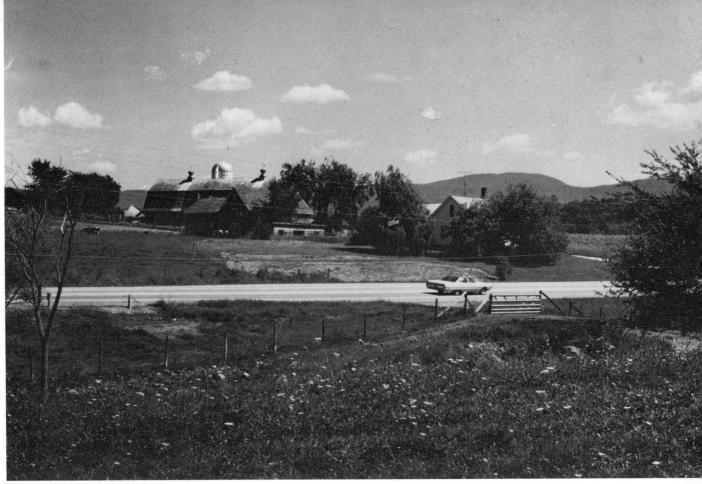

50mm

In the large photo above, the 50mm lens produces an illusion that the buildings are much further away than they actually are.

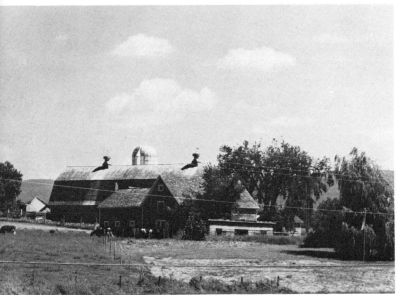

105mm

The 105mm lens produces a picture more like what I saw.

Now with a better understanding of some of the camera's limitations I will take you on a typical note-gathering excursion in the country. It started by first getting permission from the farmer to take the pictures. This may not seem necessary, but, in addition to avoiding trespassing charges, it has considerable value. You gain the freedom to go where you please, and the owner may even suggest something about the place you might not see. In this case the owner suggested that I start from across the road where his hay barn was located. It was hidden behind some trees so, I was not aware of its existence. The farmer proudly stated that the barn had already been the subject of a painting which now hung in a prominent local restaurant.

After crossing the road I took the photos on these two pages. I had with me two 35mm cameras, a rangefinder type with a 50mm lens and a single lens reflex with a 105mm or telephoto lens. I explain about cameras and various lenses in chapter 8, pages 81 to 87. Notice the difference be-

50mm

tween the bottom left photo and the one directly above it. Although both were taken from the same spot the buldings appear much closer in the lower one. This is the effect of the telephoto lens, which is why I prefer it to any other.

The long view might never be used in any painting, but it does establish the general character of the area, and this could influence the concept as well the painting.

As I skirted the small clump of trees I saw the hay barn at the top of the hill. Because the road leading up to it offered a good compositional device I recorded it with the normal lens, 50mm on the 35mm camera. The illusion of greater depth than actually existed is created by camera distortion. Yes, distortion did exist because I was standing on the road when I took the picture.

When I reached the top of the hill there seemed nothing of real interest to the barn. I shot it with the 105mm lens to give it bigness. This produced an immediacy that gave it character.

In the top photo the 50mm lens exaggerates the perspective, making the road appear longer than it is.

105mm

The 105mm lens permits you to fill the frame without noticable distortion.

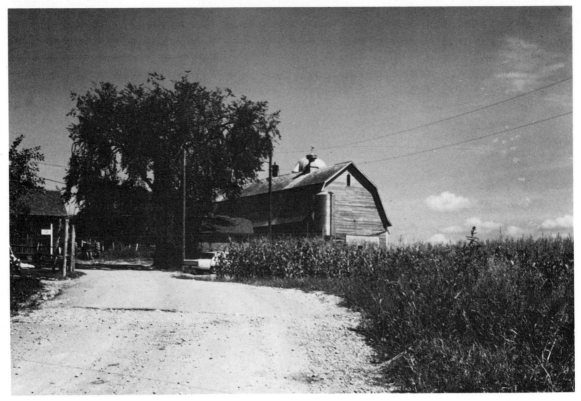

50mm

50mm

50mm

Back across the road I felt more at home. I recorded the big barn next to the cluster of trees with the 50mm lens because I wanted to keep the dirt drive as the dominant shape. The 105mm would have eliminated most of it. At the top of the drive I was in the midst of a group of buildings which could only be recorded effectively with the 50mm lens. While I was shooting these pictures, the shaggy dog tried to distract me with its loud barking. When the camera was pointed at the dog there was a sudden silence as if this was what he wanted all along. It was recorded with the 105mm. I didn't want to get too close.

Keeping the cornfield to my right – you can see it to the right of the drive in photo on opposite page – I followed a path until I was far enough away to get a full frame of the barn. It was recorded with both the 50mm and 105mm lenses, but the 105mm required two shots to get it all in.

Because the barn interested me with its shape, textures, and wealth of detail, I moved in to make a record of each part. The 105mm let me record it without perspective distortion because I was far enough away.

20

50mm

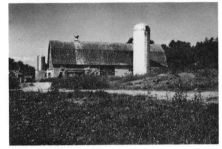

50mm

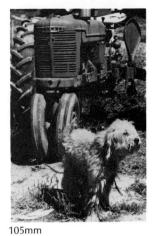

105mm

105mm

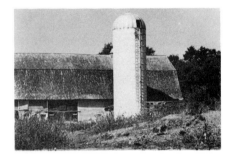

50mm

105mm

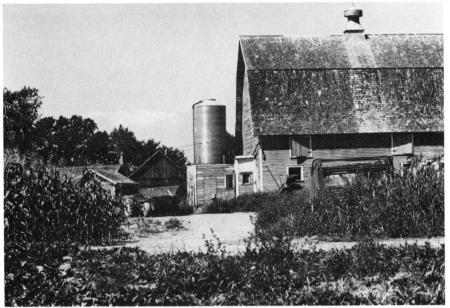

105mm

105mm

105mm

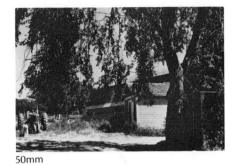

105mm

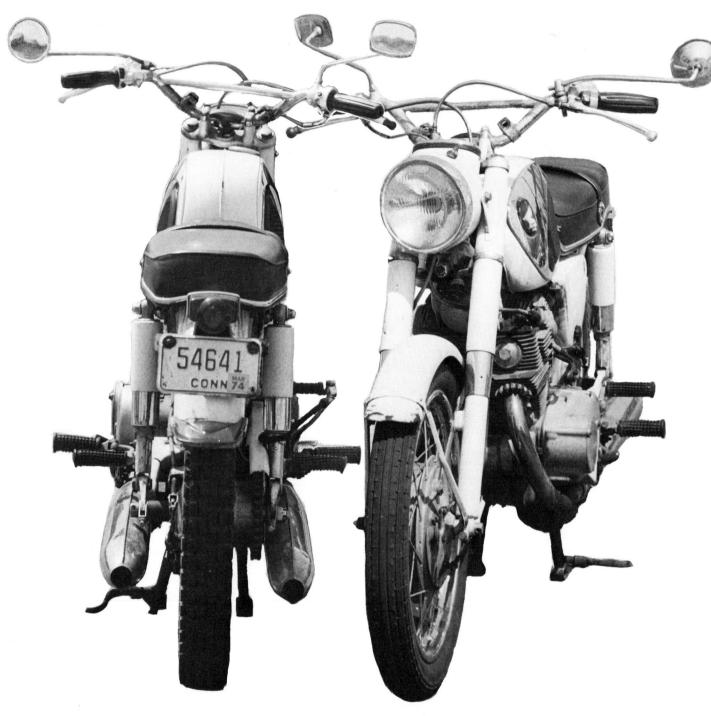

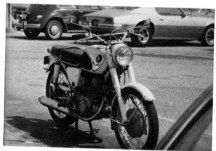
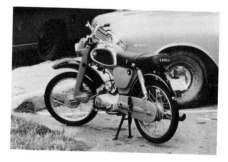

CHAPTER 2
PLANNING THE PAINTING

Every artist has a different way of planning a painting. Some are analytical about it while others are completely intuitive. However they approach it, paintings don't just happen. Something about a subject triggers a mental response which the artist translates, consciously or not, into a picture. Occasionally a subject might have such a strong appeal for the artist that it almost designs itself. And there are occasions when a single reference photo is all that's needed. For me, however, paintings rarely begin that way. They are the result of planning and research. Research may seem like a fancy word to use; however, it best describes my system for putting the camera to use. My paintings are generally based on an

initial fleeting impression or just an idea. That impression is worked on until the picture evolves. To describe what I mean, it's best to follow me in the development of a painting, *Yamaha and Suzuki at the Fine Arts.*

Although the painting was finished in the middle of January, it started several months before that, in October. I've selected this painting because it's been a milestone in my career, in that it pointed me in the direction where my interest, temperament and skills could all be used to best advantage. The fact that it won the Ted Youdain award for New England Landscape at the 1972 Silvermine New England Annual convinced me that I was on the right track.

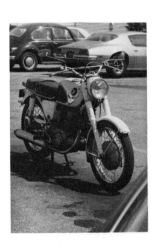 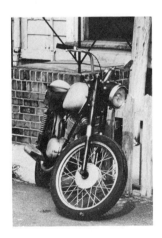 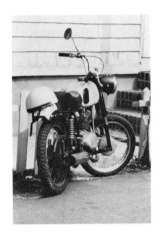 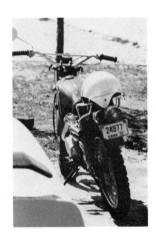

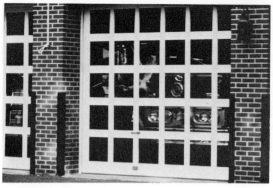

Reflective patterns were minimal in the fire house doors, above.

Right, above. The barber shop window had lots of things happening, but there was no room for a motorcycle.

Right. The entrance doorway of the Fine Arts Theatre offered exciting possibilities for reflections.

During this time several friends and associates were having quite a bit of success in selling paintings of the old and new West. I like the out-of-doors, so there was a temptation to jump on the bandwagon. But I'm urban bred and a product of today's world so I resisted the temptation. One of the principle interests of western painting seems to be the horse. What is there about the horse which generates this kind of interest? It's logical to assume that the attraction lies to a great degree in its beauty but also important is that it's a powerful, sometimes dangerous, creature which is exciting to own and ride. Now the question was, "how could I bring the horse into the city?" The answer has been there right along, but I didn't see it. . .the motorcycle. The automobile has to be eliminated because, compared to riding a motorcycle, it's more like riding a horse and buggy with a lot of other people in it.

Since I then knew little or nothing about motorcycles -- today I own one -- I began to look at them with a new interest and a fresh eye. In October, however, there aren't many around. There were long spells when I saw none, so I purchased and assembled two model-kits. One was a police bike, the other a "hog," custom-built. And,

whenever a parked cycle was found, I took a series of photos from every point of view that space would allow. In a little while I'd become familiar with many different kinds and sizes of motorcycles, domestic and imported. I was especially fond of the Honda Hawk pictured on page 23 and had definite plans to include it in a painting but later decided that it was too old a model for the situation. I was then ready to plan my painting of motorcycles, but I still had not found a way to present them.

During my excursions I'd also become interested in store window reflectons. These I photographed too. One Sunday afternoon I decided that the local firehouse might offer something in the way of interest. It didn't, but in the parking lot next door, the telephone booth did. I wasn't completely sold on the telephone booth as a subject, however, so I continued my search. Two days later, as I was walking past a local movie theatre, it hit me. There was my painting. The attractive old frame structure next door was reflected in doors of the modern brick, metal and glass building.

Naturally, my motorcycles would be reflected in the doors too. The first step was to see how my models would look reflected

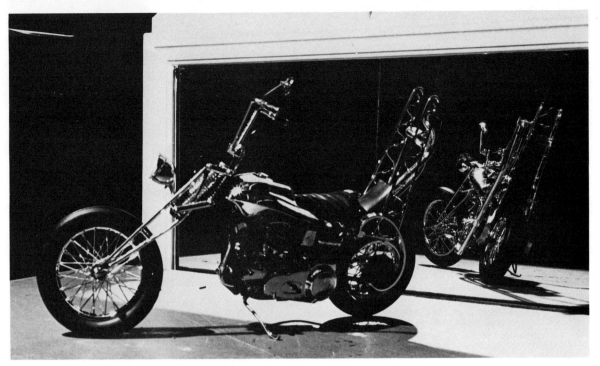

To study reflection effects, I placed a model in front of a mirror and photographed it in various positions.

in a mirror. My original choice was the hog. I didn't like what happened and I didn't like the cycle either. The only choice left open was to search out some real cycles from my slides and invent reflections. This I did.

Everything was set for the painting. It was to be an oil, on stretched canvas, 30 by 40 inches. Because I have never had any success in tracing drawings made first on tracing paper onto a canvas, I've grown into the habit of drawing directly on the canvas, first with pencil and then refining it with acrylic.

The big shape of the doorway was roughed in first, making sure that the reflected building appeared properly in the doors' end panel. Because there was so much perspective involved, I established the eye level early. It's just slightly above the stripes on the doors. To get an accurate perspective grid I placed the canvas on the floor, lining up the eye level with a nail driven into a board that was taped to the floor a short distance away. This represented the right vanishing point. To the nail I attached a string which had been rubbed with pastel. By pulling it taut across the canvas I snapped it at various angles to establish the grid. The same thing was done

for the opposite vanishing point except that the string was coated with a different color pastel. This was sprayed with fixative. The doorway and reflected building were then drawn with little difficulty.

Next came the bricks. Having counted the rows that I could see in the photo I divided the height of the doors into that many equal spaces allowing for the mortar between the bricks. Using a T square and a triangle every brick was drawn to scale.

Although I wanted to show motorcycles reflected in the glass of the doors I'd made no sketches nor decided which motorcycles I should use. The Yamaha and Suzuki were selected because they were obviously different.

The drawings were roughed in on paper which were then cut out. I taped these to the canvas where they seemed most likely to fit. It took a few drawings before I was satisfied with the scale and relationship of the cycles. Before removing the paper, lines were traced around each piece to give a reasonably accurate guide for the final drawings. These were done in pencil and finished in acrylic.

The painting then proceeded without difficulty.

Overleaf, YAMAHA AND SUZUKI AT THE FINE ARTS
Although the reflection of the foreground Yamaha would appear naturally in the right panel showing more of its side, I changed it to produce greater interest and to keep it within the confines of my composition.

25

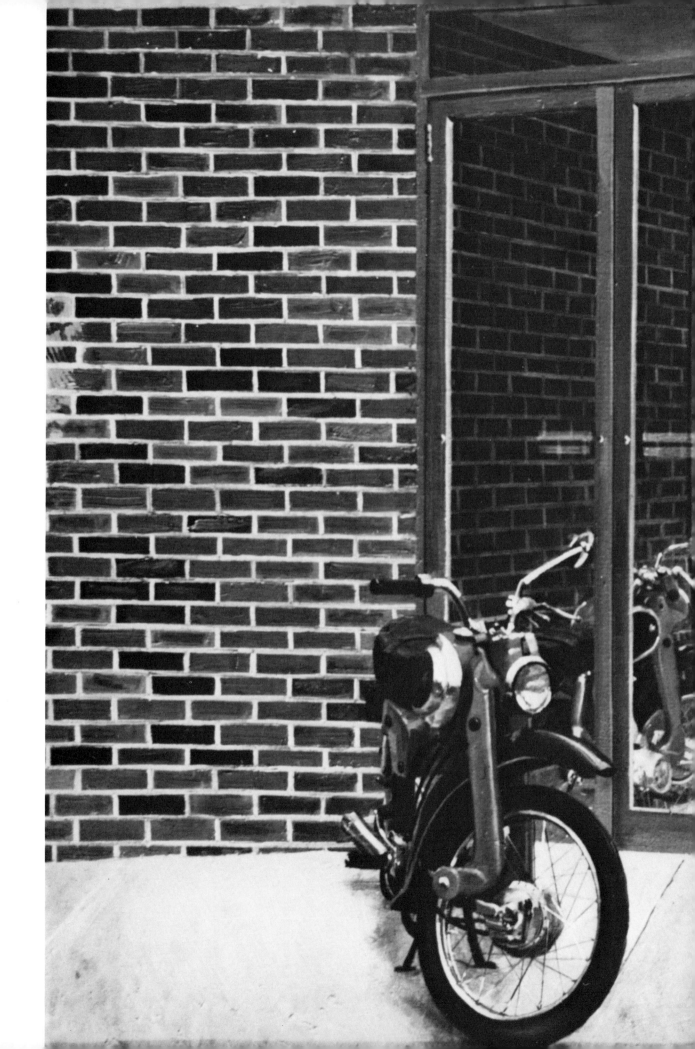

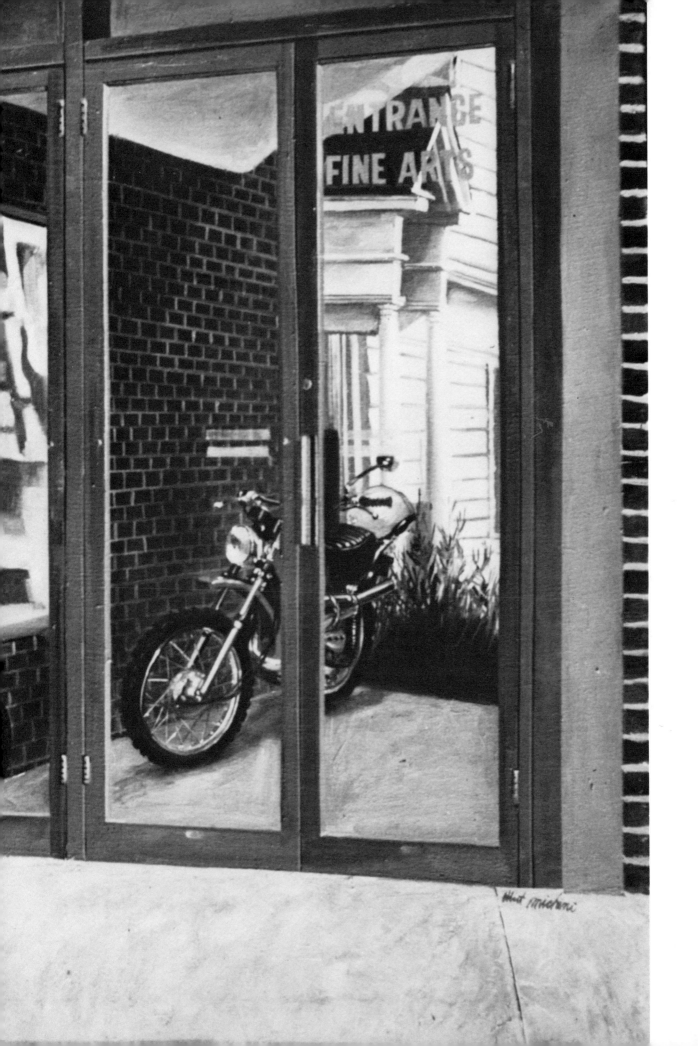

Shortly after completing *Yamaha and Suzuki at the Fine Arts,* I realized that enough material had been gathered for a second painting. The phone booth slide contained an interesting shadow pattern which was almost a repeat of itself. The junction boxes on the wall also helped. Of course there had to be a motorcycle in it as well. The choice was to put in another Suzuki. I liked the way it leaned on the kick stand while its slim front forks and raised fender gave it that ready-to-go look which fit the title, *At the Hitching Post.*

Whereas the phone booth is lit from the front, the motorcycle is lit from behind giving the illusion that the sun is pouring down its light in a narrow beam. Although some perfectionists might consider it inaccuracy, the illusion is an effective one. It's enhanced by framing all the elements in a tall narrow shape.

Once a painting is finished I tend to ignore the old slides and they often wind up on a shelf uncataloged. I've gathered what I could find to reconstruct the procedure. Although most are here, a few important ones are missing.

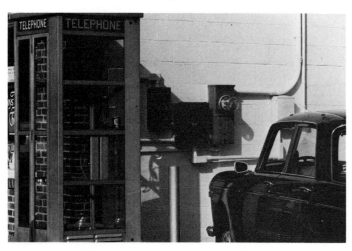

Above right. A newer Suzuki was set up to duplicate my original photo that has been misplaced.

Above. This is the original photo used for the painting. The small area of parking lot was invented.

Right. View of the phone booth looking back toward the parking lot.

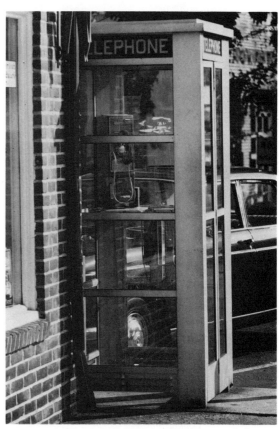

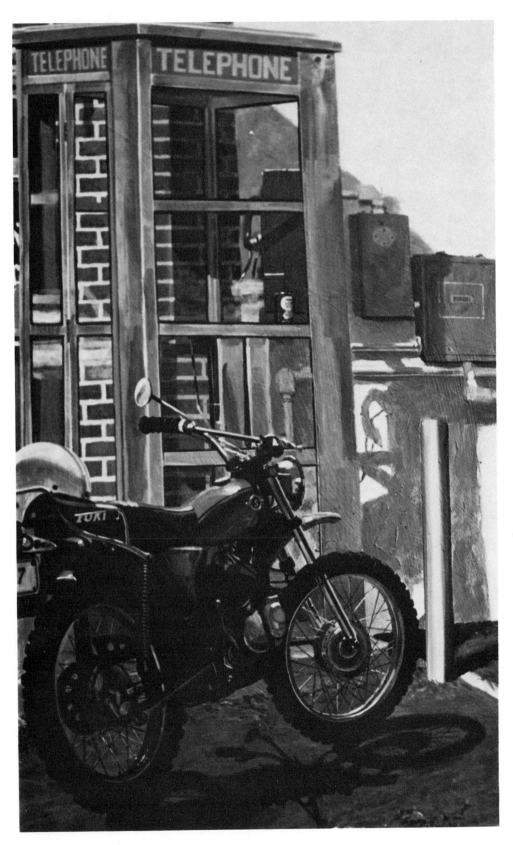

AT THE HITCHING POST

CHAPTER 3
PUTTING IT TOGETHER

THE CASTLE ON FARM CREEK

In the last chapter we saw how the camera was used to help develop an idea. Although some paintings are made that way, most are not. Usually it's a familiar subject that finds its way onto canvas. In my case the outstanding landmark in my immediate neighborhood, except for the tidal marsh, is a magnificient stone mansion. Most homes here are frame, but this is a stone castle-like structure. I simply had to paint it.

Although the castle-like character of the building is more apparent when looking North from across the marsh I preferred to depict it from the near edge looking East. This is the view with which I'm most familiar. Unfortunately it appears cold and remote, surrounded by its cluster of trees and expanse of marsh grass. To overcome this I chose a 135mm lens for my 35mm single reflex camera. The bigger image helps alleviate some of the remoteness while the warm Fall colors stop out the cold.

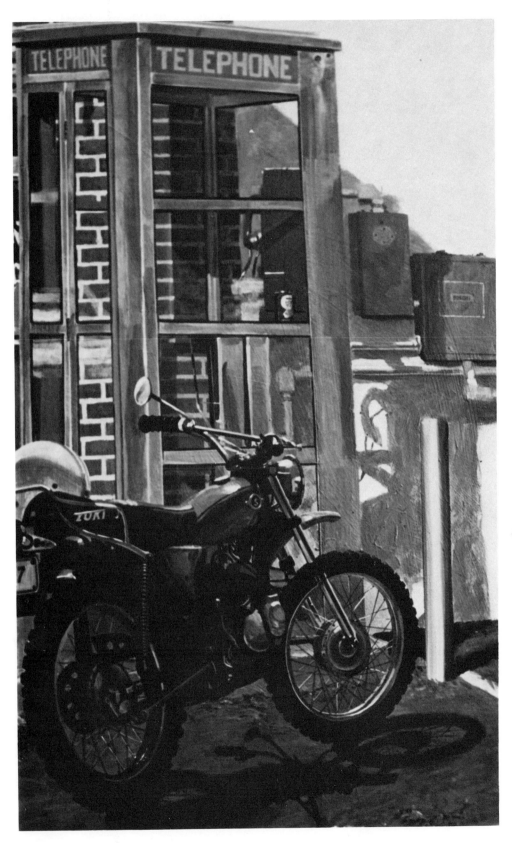

AT THE HITCHING POST

CHAPTER 3
PUTTING IT TOGETHER

THE CASTLE ON FARM CREEK

In the last chapter we saw how the camera was used to help develop an idea. Although some paintings are made that way, most are not. Usually it's a familiar subject that finds its way onto canvas. In my case the outstanding landmark in my immediate neighborhood, except for the tidal marsh, is a magnificient stone mansion. Most homes here are frame, but this is a stone castle-like structure. I simply had to paint it.

Although the castle-like character of the building is more apparent when looking North from across the marsh I preferred to depict it from the near edge looking East. This is the view with which I'm most familiar. Unfortunately it appears cold and remote, surrounded by its cluster of trees and expanse of marsh grass. To overcome this I chose a 135mm lens for my 35mm single reflex camera. The bigger image helps alleviate some of the remoteness while the warm Fall colors stop out the cold.

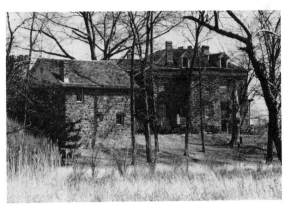

I started walking toward the building until it nearly filled the viewfinder.

As I walked back, I recorded the field of grass.

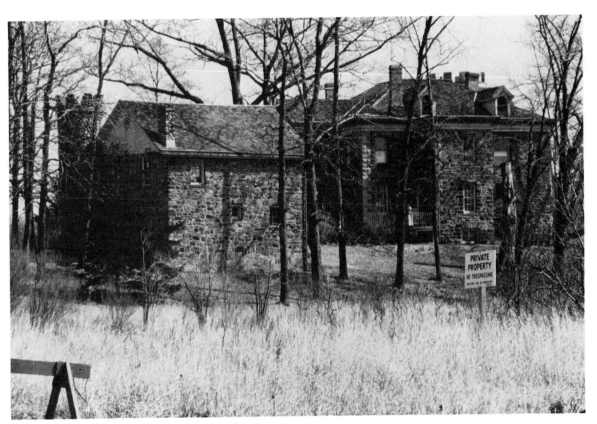

The smaller area of lighter foreground grasses, with the building only slightly further away, seemed best suited to the subject.

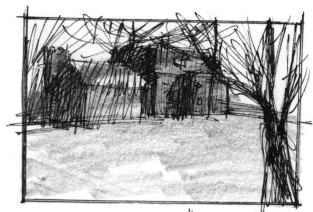

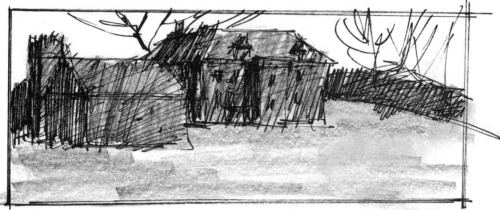

My first compositional sketch was more or less like the slide except the building was raised somewhat to allow for a bit more foreground. The tree was introduced to add to the illusion of depth while creating foreground interest. In the second sketch the scene was expanded to produce an area more suited to the building's size and shape while keeping it close to the viewer.

There were doubts about the long sketch too, so I tried a vertical shape that was closer to a square than a rectangle. The mansion was again placed at the top with a rhythm of dark shrubs swinging behind it. A curving dark shape was introduced into the foreground as well.

A different kind of foreground was put in the finished painting. Although dark like the sketch, most of the motion occurs within it like ripples on the sea. The upthrusting tree stump forces a jarring relationship between marsh grass and building that ties them closer together than the romantic dark shape of the sketch. To soften the blow of this contact between tree stump and building, the ground on which the building stands rises in a graceful curve.

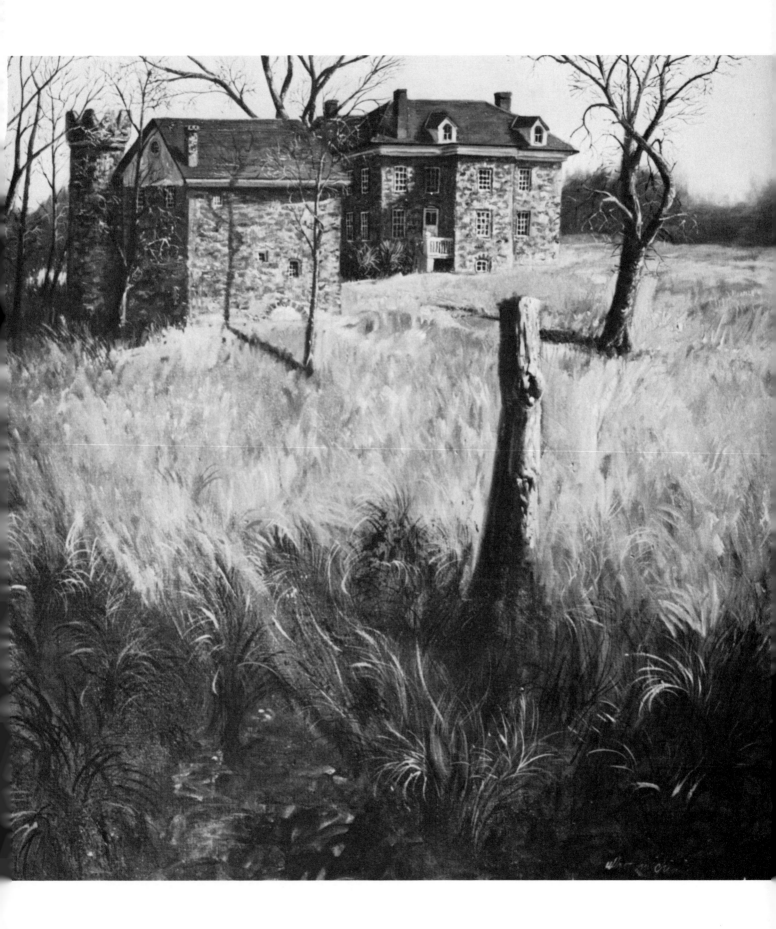

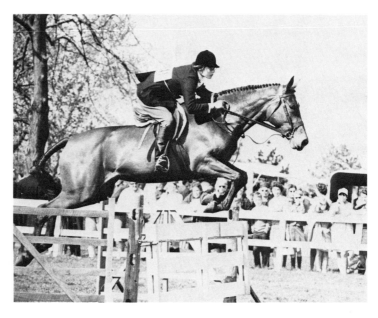

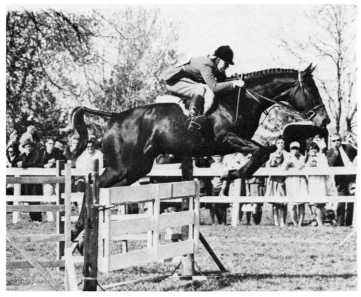

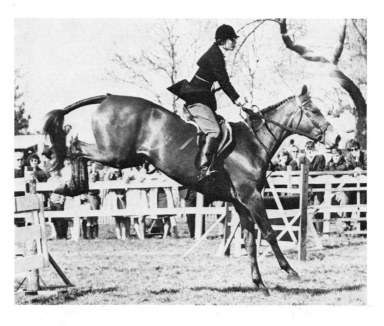

OVER THE FENCE

No subject on the camera can be complete without covering stop action. Animals are among my favorite subjects. I'm especially fond of horses, which may explain my affection for motorcycles. At a horse show I chose a spot near one of the jumps. I used the fastest shutter speed possible, 1/1000 second, on my single lens reflex camera with a 135mm telephoto lens. As you can see, the combination of fast shutter and telephoto produced big sharp images. The horses and riders are frozen in an instant of time for as long as these pictures last.

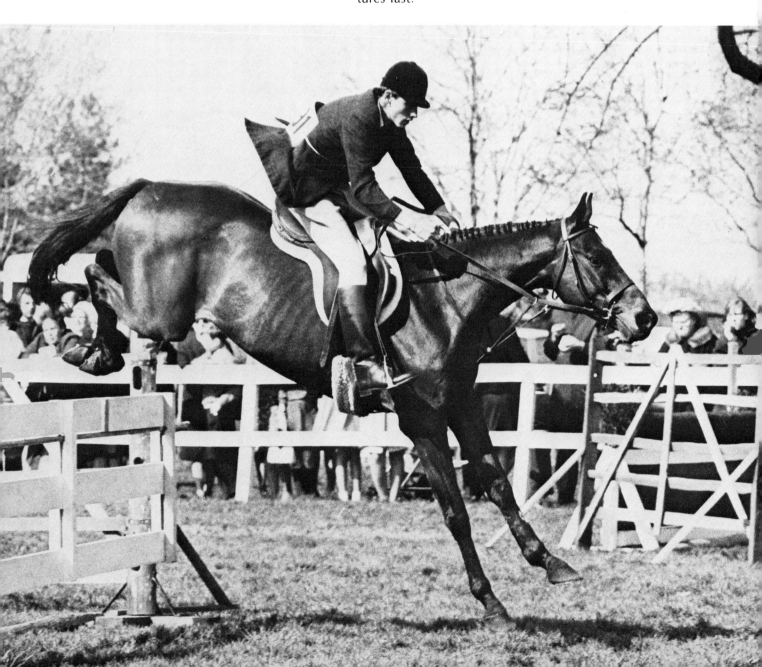

From all the pictures taken, four were chosen as suitable for my intention, which was to combine two or more horses and riders in some kind of competition, a race perhaps. In the two finally selected, the horses were attractive with a good value pattern and the action of the riders was good: the young woman exhibits good form and intensity, while the young man seems less in control with his forward lean which complements the stiff front legs of his mount.

My first sketch proved to me that the horses combined well, but didn't work with a blank background and the show fence. Something else was needed although it was my intention all along to work with a vignette because the finished art was to be a pen and ink. Under *trees* in my file-photos, drawings and whatever catalogued under different titles to be used for reference -- I found a blossoming apple tree, opposite page, with the perfect rail fence. I then made the second sketch. The rail fence, because it extends beyond the lead horse and ends with the two vertical posts, helps to hold the action within the border of the picture.

The final pen-and-ink drawing was first drawn in pencil directly on the illustration board. I prefer this approach to the tracing paper method because first it is a drawing and secondly, the pencilling is not complete. The pen is used for this. It allows for more flexibility.

I used a Rapidograph pen with a 00 nib for the rendering. Using consistently fine lines, value patterns were built up like any other halftone rendering. Although a somewhat tedious process, the rich black and gray values make it well worth the effort.

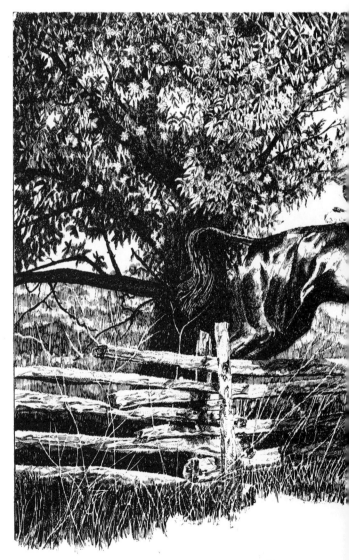

This photo of an apple tree was selected from my files. When added as a background, the rail fence suggested a longer shape for the final drawing which was executed in pen and ink.

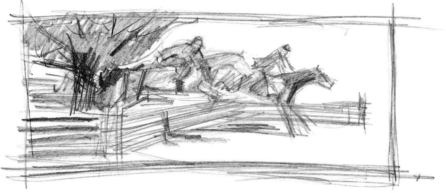

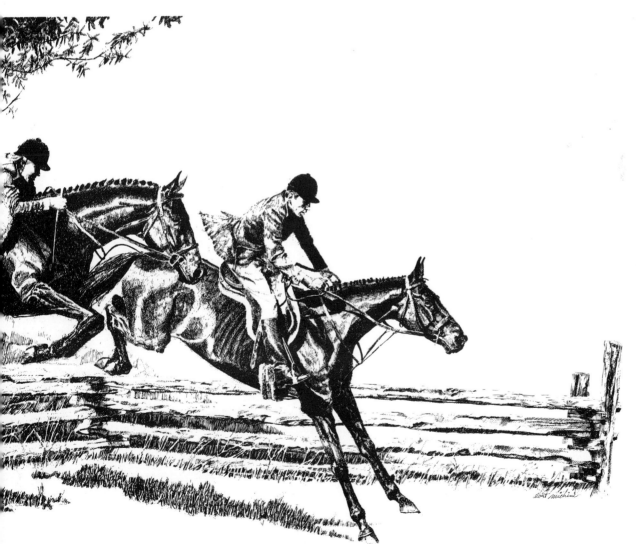

PORTRAIT COMMISSION

What at first might seem like an impossible assignment can turn out to be one of the most rewarding. The camera really helped. I was commissioned to do a portrait of a man in the uniform of a Rome policeman, Carabinieri, from small photographs taken almost thirty years ago. These are reproduced same size on the opposite page. The subject for the portrait is the policeman on the far right. Fortunately, the larger portrait photograph of the subject taken about the same time was also included. Since it was to be a surprise Christmas present for the subject, there would be no opportunity to meet him before the completion of the painting.

The man's stepson described the requirements: the subject, in full uniform, standing in front of St. Peter's in Rome on a panel 30 inches high by 24 inches wide. At that time I executed the rough sketch, opposite, which gained his approval. I was ready to go ahead.

The task began with making the photographs large enough to see. This was done by copying them on film, then making enlargements. Fortunately, I own a 4 x 5 Crown Graphic camera that I purchased used over ten years ago and is still in excellent condition. I also have a roll film back for this camera. The normal film comes in sheets 4 x 5 inches. The roll film back permits me to use 120 film which is 2 1/4 inches square -- see pages 88 and 89. The Crown Graphic camera is a view camera which focuses the image upside down on a ground glass. To see the image clearly the photographer must cover his head and the camera back with a hood to block out all

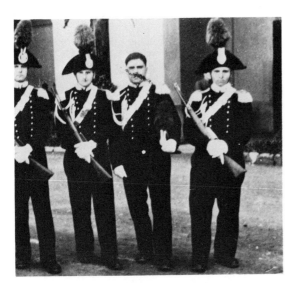

Same size snapshot of the subject in uniform.

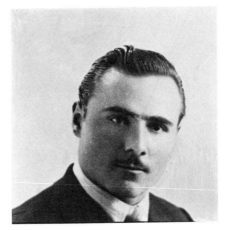

This wallet-size portrait was furnished to me to be used for the likeness.

extraneous light. Since the camera normally accepts a much larger negative, I have drawn black lines on the ground glass for the 2 1/4 inch size. When the image has been properly framed on the ground glass, the back is removed. Spring type clips are released and then the back can be lifted off. Without moving the camera, which has been firmly mounted on a tripod, the roll film back is slid into its place. When firmly locked in position, a slide covering the film area is removed and the picture can be taken. I did this on a cold November day in my driveway in daylight, which is the best light available for making copies. The exposure on Professional Plus X 120 film was F11 at 1/125 seconds.

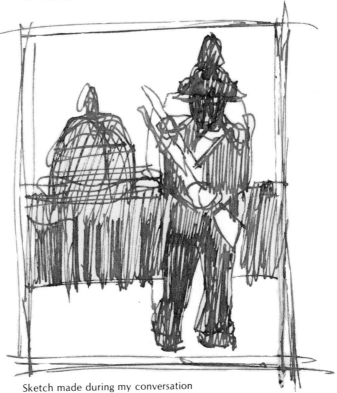

Sketch made during my conversation with the client.

In my file under *Italy* I found the photo of St. Peter's. It suited my needs perfectly. I then made enlargements of the copies eliminating the other policemen. One print was made very light so that I could determine the folds and details within the dark uniform. A dark print was made for the light areas. Between the two prints I could see everything that existed in the original without difficulty.

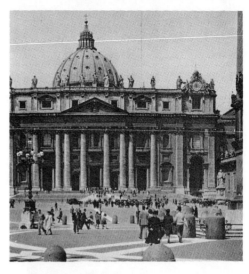

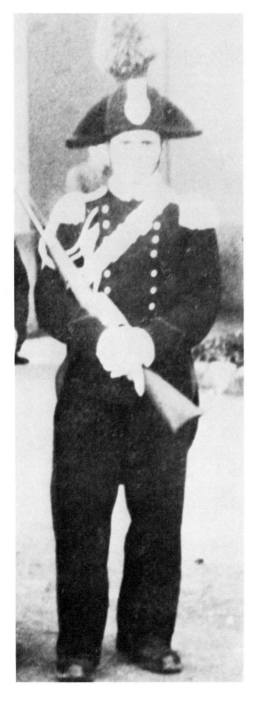

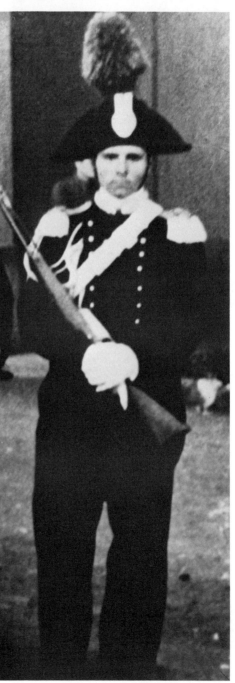

I posed myself in the action of the subject to establish a light and shadow pattern consistent with the portrait photo. This also gave me a clearer description of the folds.

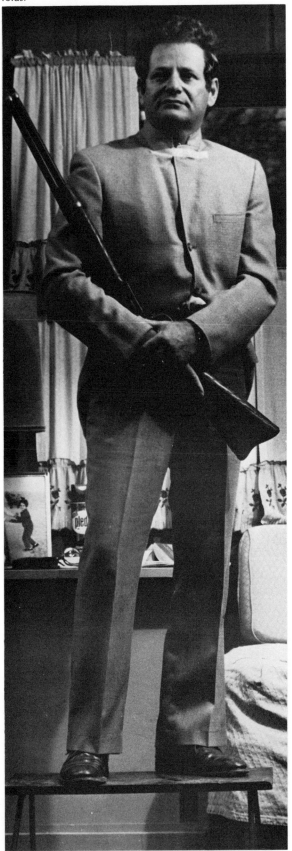

Although the two prints were considerably better than the original they were not quite enough. I selected a short rifle from my plastic gun collection, produced a make-shift uniform by taping up my coat collar, established a light source similar to that in the portrait photo, and had my wife photograph me from a low eye level. The camera was on a tripod and about level with my knees -- see next page for eye level explanation. To avoid the common distortions a 105mm telephoto lens was used. After I saw the prints, however, it seemed that perhaps a longer telephoto would have been better: 135 or 150mm to eliminate the worm's-eye view angle to the head. But the distortion also produced a plus, causing my head to appear smaller, thereby adding height. All this wasn't really relevant, because the photo merely served in a supportive capacity.

I would like to diverge for a moment to continue with the discussion of the telephoto lenses. You'll notice as we progress through this book that the 105mm telephoto lens is the one preferred over all others. The reason is that this particular focal length -- see pages 86 and 87 -- records what one normally sees more accurately than any other. Shorter focal lengths include too much, longer focal lengths too little.

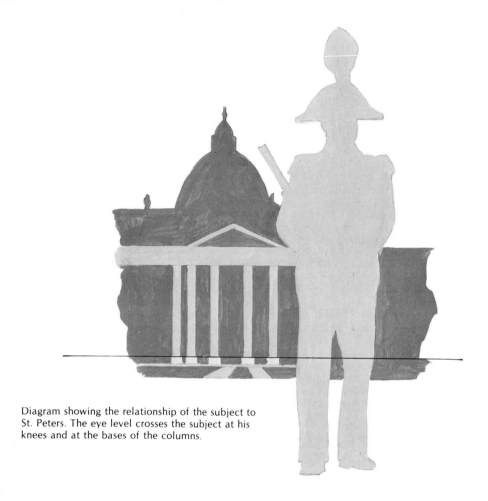

Diagram showing the relationship of the subject to St. Peters. The eye level crosses the subject at his knees and at the bases of the columns.

The drawing for this commission was rather easy to do. Ignoring the headgear I drew a figure on tracing paper with the head as the proportional unit of measure. When it was completed to my satisfaction, I then drew in the hat.

If you look past the baroque ornaments on St. Peter's you'll see that it's a rather simple structure to draw. The building, however, is not wide enough to fit the subject in between the dome and the clock. A line was drawn through the photo and eventually on the tracing paper. Later, when the drawing had been completed, I cut it on that line and fitted the pieces on either side of the figure. But I'm getting a little ahead of myself.

To draw the building in relation to the subject I slipped the figure I'd drawn earlier under a clean piece of tracing paper on which the outline of panel has been indicated with a black ink line. When the figure was located where it seemed in the best relationship to the shape around it, I

taped it down. A black line was drawn in ink across the page at the subject's knees. This was the eyelevel line which I'd decided earlier would cross the building at the base of the columns -- see diagram above. In reality this is an impossibility because the pedestals are located at the top of a long flight of steps high above the subject's head. But there's a special exception to the rules of perspective: *if it looks right it is right.*

The building was then roughed in -- on the left side of the subject only -- until it looked right. Finally satisfied with the relationship, I removed the drawing of the figure and completed the building. It was cut apart as I described earlier. I taped the separate pieces of the building, along with the drawing of the subject, to a previously prepared panel and traced down. The vanishing points were established on the eyelevel line and the white markings were drawn in. The painting was finished in acrylic, following a procedure quite similar to that described in the next chapter.

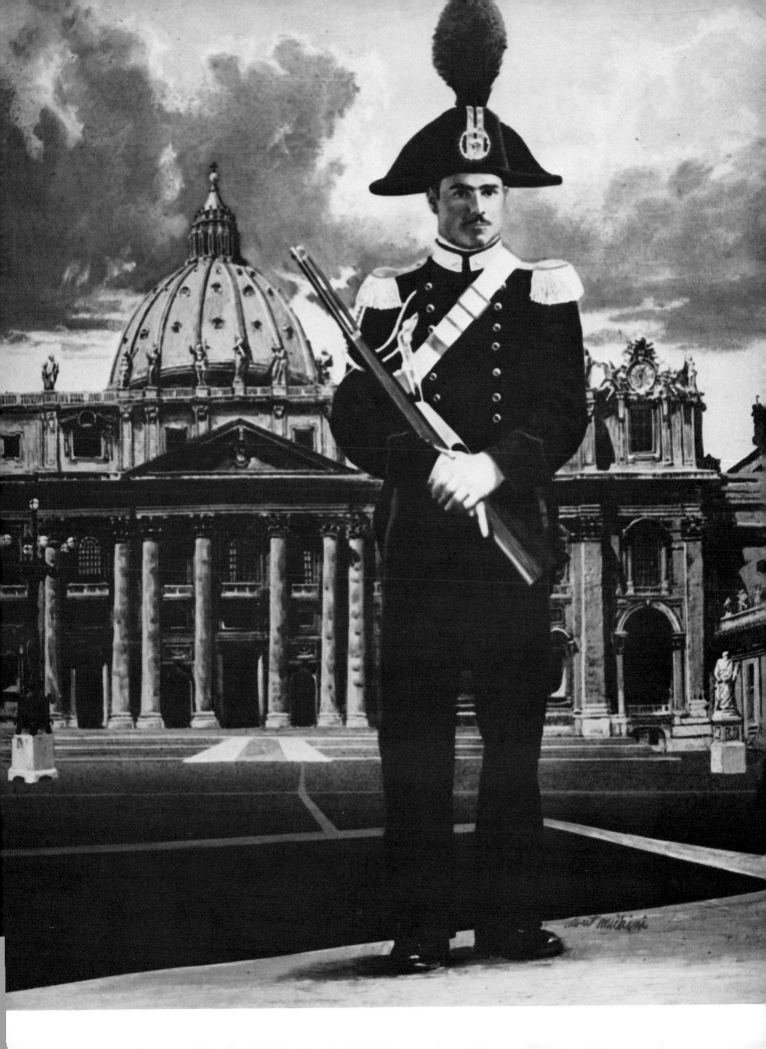

CHAPTER 4
PAINTING FROM PROJECTION

It was snowing when I went to bed that Saturday night, so I set my alarm for an early hour. I wanted to record the blanket of white before the Sunday activities had marred its surface. As I left the house the gray twilight of dawn was giving way to the cold diffused light of a sunless morning. I trudged through drifts of knee-deep snow to the river. In the boatyards the gray tent-like boat covers wore towered white caps, while gusts of wind blew the fine white powder into soft mounds around the supporting

I was looking down river when I turned and saw the cemetary with the giant maple.

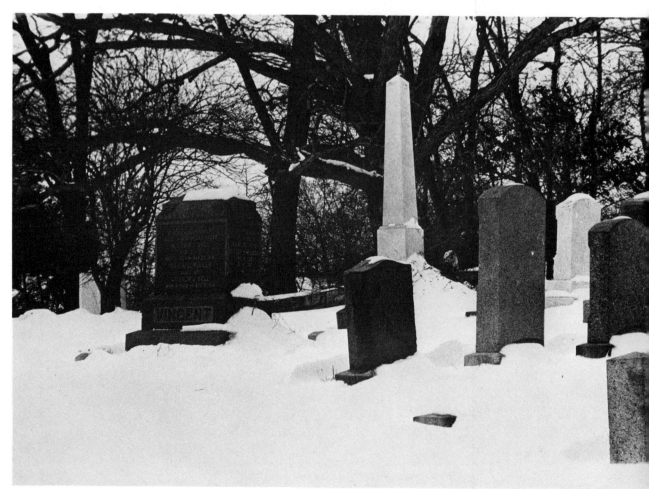

44

beams. Mine were the only footprints as I
walked through. Picture opportunities
abounded. The river at low tide was a series
of frozen white hummocks with a ribbon of
icy gray water meandering through it. A
white house on the other side of the river,
its shape lost against the snowy background,
presented a mosiac of black shutters. As I
left the boatyard a gargantuan orange snow
plow scraped past, blowing a fine cloud of
the white powder in its wake. Where the
road curves toward the river it opens onto a
view of the entire harbor clear through to
the Sound. All of this was recorded on film.

There were just two pictures left on the
roll when I happened to turn around. On a
hill overlooking the road the stark shapes of
cemetary monuments pushed through the
cover of snow in front of a lacy pattern of
branches, dominated by the bulk of a giant
maple with its enormous black arms
reaching in every direction. This was to be
my painting.

Later as I painted this picture, I could
feel every emotion that inspired me on that
Sunday morning except the cold. Next to
me, on my drawing table the slide shone
brilliant on the large 20 X 30 inch rear
projection screen as described on pages 94
and 95.

Although the vertical composition
comes closer to my first impression of the
scene, the long horizontal shape better
describes the effect it had on me.

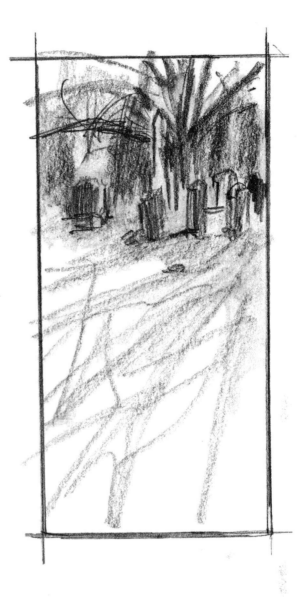

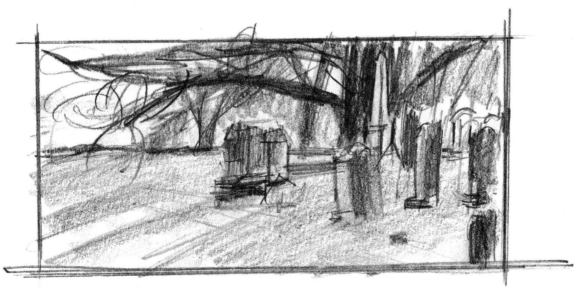

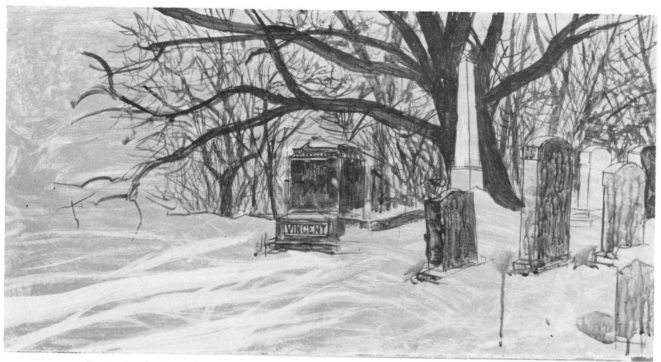

Step 1. Drawing in acrylic on a gray ground.

The painting was to be done in acrylics. I prepared a Masonite panel 15 X 30 inches by coating it with three applications of gesso. With a mixture of cobalt blue, raw sienna, and white acrylic, I produced a ground color for the painting. This was applied by rubbing it on with my hand and fingers to allow for happy accidents. While it was drying I placed it on the easel, turning it upside down several times to decide which presented the best pattern of lighter areas. The decision made, I sketched in the big shapes with pencil.

Using a dark warm gray which was a combination of ultramarine blue and cadmium red pale, I completed the first stage. I accomplished this by drawing in the dark shapes, exercising some care as I did so. It was imperative that I establish the right character for each object. I made corrections by wiping out with a wet tissue. When the dark shapes were drawn in to my satisfaction, the lighter values were washed in. There was not a full range of values from the middle to dark. The lightest value was put in with slashing streaks of warm white -- a mixture of white and yellow ochre -- to suggest the light of a low winter sun.

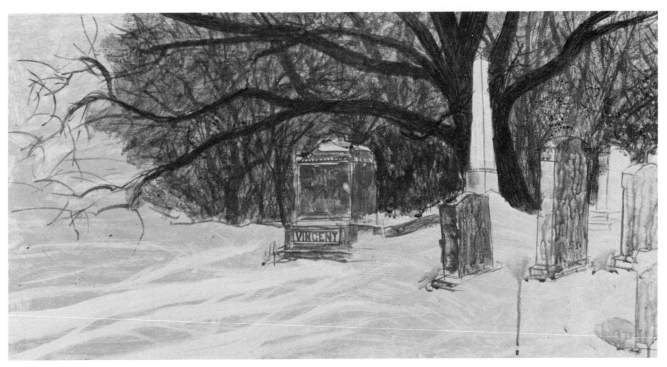

Step 2. A dark brown shape is painted in the background to suggest the trees.

A wash of raw umber was applied over the entire area of the trees. I made no effort to suggest various trees or branches. To keep the wash from being too flat, I pushed the large brush hard against the surface, then lifted and pressed hard again. There was no definite pattern or plan to this exercise. No acrylic medium was added to the wash because the effect with it would not have been in character with what I'd do now. Also, the medium would have made the wash more transparent, which I didn't want. The purpose of the wash was to pull all the separate trees into a single tonal mass. Some of the trees were accented with a cold gray, which was only slightly darker than the surrounding areas. The paint was applied in short strokes over the tree surface, allowing some of the underlying value to show through between the strokes. These strokes were not carried out to the edges of each shape so that the trees would remain soft and indefinite as part of the wooded mass.

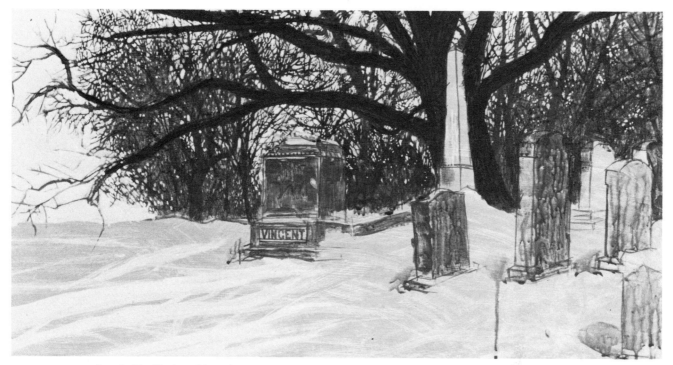

Step 3. The illusion of branches was established by painting the sky around them.

The next step was probably the most tedious and most important part of the painting: putting in the sky. I wanted the color to be a warm gray without being sure of exactly what. Experiments with blues, yellows, and ochres didn't prove satisfactory. It seemed that the yellows, ironically enough, produced a gray which seemed cold next to the umber of the trees. I tried adding cadmium red pale. The pinker it got, the better it looked -- experimenting in the corners -- until I finally settled on a gray that was almost pink. There was no fear of running out of this color, because by then I had mixed a big gob of it.

The most time-consuming effort was the process of painting the sky around and through the branches. You may wonder why I didn't simply paint the sky first and draw in the branches afterwards. The answer is that I'd tried that in other paintings, but they looked fussy and mechanical, while not achieving what I was after: the light spilling through the branches. Interestingly enough, I didn't have to make any real attempt to in-

dicate individual branches, because I was painting the light not the branches. It was tedious only because the shapes were small. I used a number three red sable watercolor brush which held enough paint so that I didn't have to keep dipping in for more.

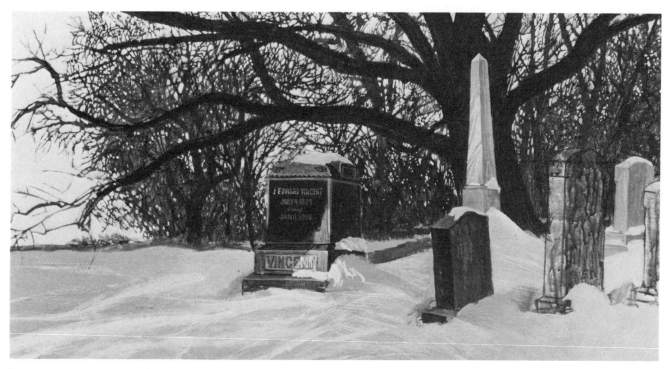

Step 4. The large tombstone is completed.

The large tombstone was painted next. Although it and all the other tombstones were gray, I decided on a reddish brown for the largest one while the others would be both warm and cool grays.

The first step in painting the large tombstone was to establish those areas struck by the slanting sunlight. I made this very warm. Cooler darker values of the same red/brown mixture were used for the areas in shadow. I'd let the ground color show through for the snow in shadow.

Because there was so much type on the stone it seemed foolish to try to include it all. I decided on a simpler arrangement, but it took a number of tries before all three lines turned out well.

The painting progressed smoothly, if not dramatically, from that point. After the final tombstone was completed there remained only the finished touches to perform. In the snow the haphazard slashes of warm whites had taken on real meaning. These needed refining to have them in keeping with the rest of the painting.

The most exasperating part of acrylics for me is not really the fast drying, but that the paint dries a slightly different color and value than it appears when wet. Refining and matching the slashes of warm white against gray with all the subtleties can become extremely frustrating. I have found that by using opaque color thinned considerably -- but not a transparent wash -- soft blendings can be achieved. Starting with a warm white I began by painting short strokes into the grays. Then with grays I painted short strokes back into the white. The best part is that no dramatic changes occur. By simply repeating with the white or gray, areas that didn't turn out quite right can be resolved. With this method I softened the slashes and suggested all the other color and value changes in the snow.

Only the great maple needed to be finished. With a mixture of burnt umber and ultramarine blue I made a warm black. I refined the branches and drew in some others using the same number three red sable that was used for the sky. Some texture was added to the trunk with short, lighter gray strokes; then I accented them with the warm black. I put in touches of cool light gray in the crook of the trunk to suggest snow. The painting was finished. To be sure that it was dry, I waited another twenty-four hours before spraying with an acrylic varnish.

WITH A VIEW UP THE RIVER

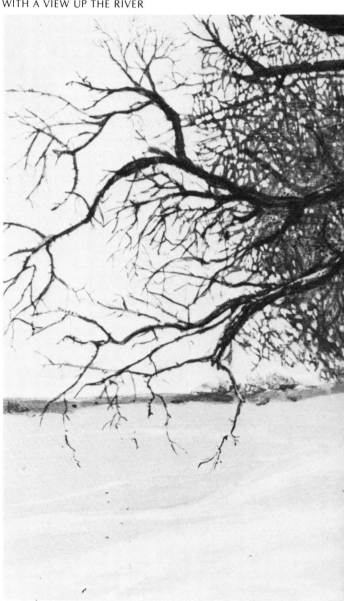

The finished painting

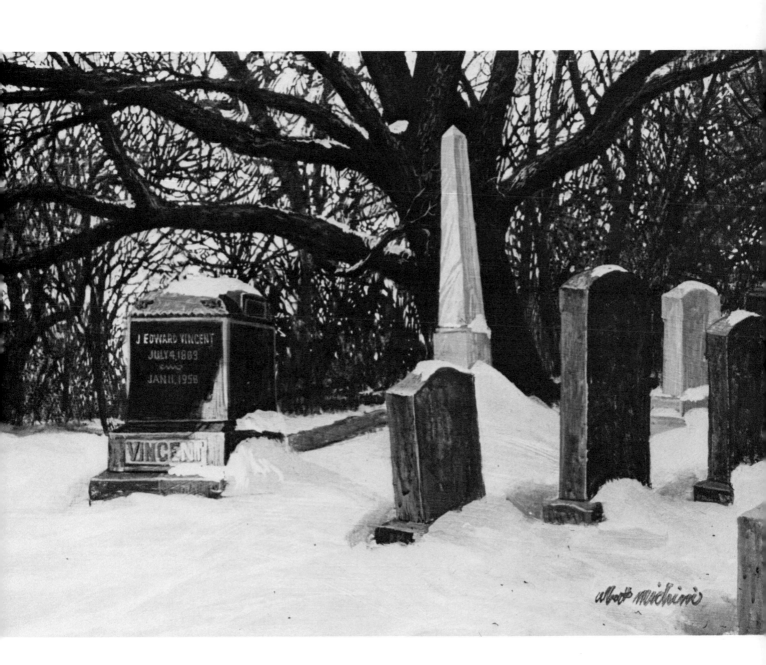

CHAPTER 5

TAKE ADVANTAGE OF YOUR PROJECTOR

Transparency of the subject.

The image is projected onto a toned panel and sketched loosely in acrylic. The room needn't be dark. Just avoid having extraneous light strike the surface of the panel.

The slide projector is a valuable tool in the studio, not for just viewing pictures but for drawing and putting things together. By projecting the image on the painting surface it can be traced quickly and accurately. This is especially helpful when striving for an exact likeness in a portrait. There are pitfalls in this approach, however, the most important of which is that it will not help you to draw better. In too dark a room difficulties will occur due to the inability to see what you're doing. I can offer, I believe, helpful hints for solving both problems.

When using the projector the room should not be dark. Just keep extraneous light from striking the painting surface. For this demonstration the ceiling lights were put out and the shade was drawn on the window just behind and to the right of the easel. The other seven windows including the window which is directly opposite the easel were left uncovered to allow in plenty of light, none of which struck the canvas. For this demonstration I'll begin with a toned surface.

Good drawing is not the mechanical rendering of just an outline. It must establish the forms as well as the shapes. To gain some of that feeling of form trace the photo by drawing with a brush. As part of the same process establish some of the tonal masses as well. The addition of white completes the value pattern. This is not a mere tracing but a complete study.

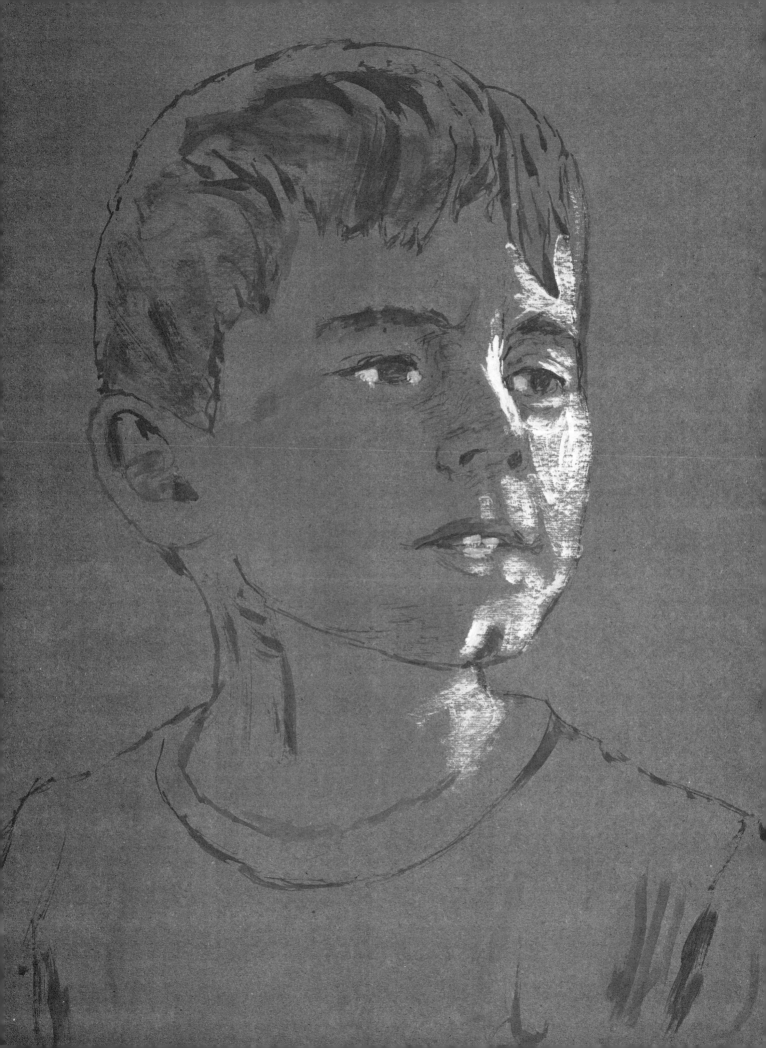

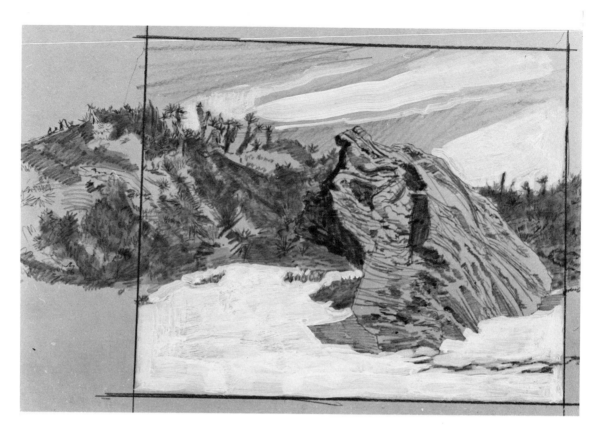

The projector can also be used for composing the painting. This can be done most simply by projecting the image on the canvas, then moving forward or back until the subject fits the shape of the canvas.

The projector is especially handy for reviewing what you've got when it's all on separate slides. As so often happens when travelling it is impossible to fit the subject into a single shot. This happened to me on a bike ride in Bermuda. I was attracted by an interesting outcropping of rock along the beach. With the waves lapping at my feet I was forced to record this scene in four separate photos.

Starting with the middle slide of the rock I projected it to just right of center on a large sheet of kraft paper. It was loosely sketched in while establishing a value pattern at the same time. The same procedure was followed for the other three slides. I had to make minor adjustments in alignment because each frame was cropped to gain all the pertinent information with only a relative interest in how they might match up. Upon completion it was obvious that the picture was too long for my needs. Frame lines were drawn in. This was followed by the addition of white paint to complete the value pattern.

Four separate slides of the subject were combined through projection to form a single image. Crop marks were added to suggest the final composition.

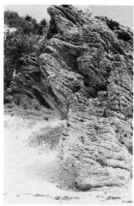

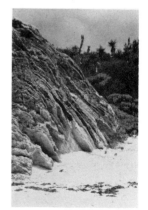

When my wife and I returned to our motor bikes, they presented an interesting arrangement which I'd been aware of when we parked. Because the direction of the light was different -- over my right shoulder -- than it had been with the beach photos, I turned the bikes around to light them from the same direction just in case they'd be included with the beach scene. It's a good idea when taking separate photos in a given area that you keep the light source as consistant as possible -- see pages 108 and 109 -- because with related photos everything will fit; and in the finished painting, everything must.

The projector is again brought into use when establishing scale, or relative size. For this demonstration the motor bikes are ideal. By adjusting size and location, the relative scale can be decided upon when the object appears natural in its new surroundings.

For a projection table (especially helpful for rear projection) I use an adjustable hospital table which was purchased at a tag sale for five dollars.

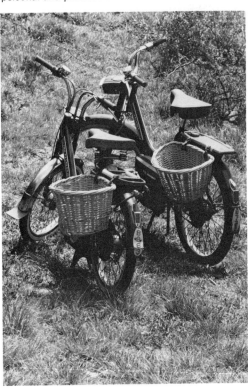

Adding our motor bikes made the painting more personal and provided a center of interest.

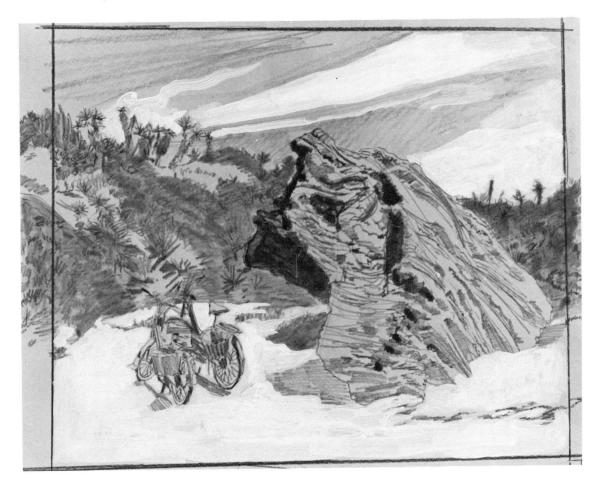

The image sketched accurately with pen and pencil.

It's with the very complex subject that the projector can prove to be a real boon. In the case of the motor bikes, I decided to include them in the painting of the beach and the projector was a great help with mechanical details such as the location of all the spokes. If it suits your purpose, the slide can be projected either on the canvas or tracing paper. It could also be projected on the nearly completed painting for comparison.

I personally find that tracing over the projected image is both tedious and boring, while not telling me enough about the object. Establishing just the general character and basic relationships is more helpful because, in the process of drawing, I better understand what it is that I'm looking at.

Whether the subject is simple or complex, the projector is yours to take advantage of as you see fit.

CHAPTER 6
FROM START TO FINISH

This chapter is concerned with one of my most recent paintings. Since my pictures had become increasingly more finished and detailed, it bothered me that in the process they had become too, for lack of a better word, slick. I'd been experimenting with an approach that is called a pointillist or stipple technique. I reasoned that the same high degree of finish could be established, but on close inspection would offer a pleasant texture that would also be decorative. The technique is much like that used in egg tempera. Instead of short brush strokes there would be dots. This chapter will describe the processes involved in the planning and execution of a portrait of my daughter, Suzanne. It will also describe how I worked within a shaped panel.

The painting started at the kitchen table which is located in an area surrounded on two sides by glass. One evening during dinner I noted with great interest the light from the setting sun as it spilled around Suzanne's head and shoulders. Although I'd selected another subject for the experiment, Suzanne seemed to be a better choice. When I brought up the subject, it was received with little or no enthusiasm until I suggested that the painting would also include Cinnamon, our dog. The action would be a simple one. Suzanne would sit, on a bench perhaps, with Cinnamon by her side. I envisioned it as a strong simple design. Since today's little girls seldom wear dresses, Suzanne would be shown in shirt and slacks.

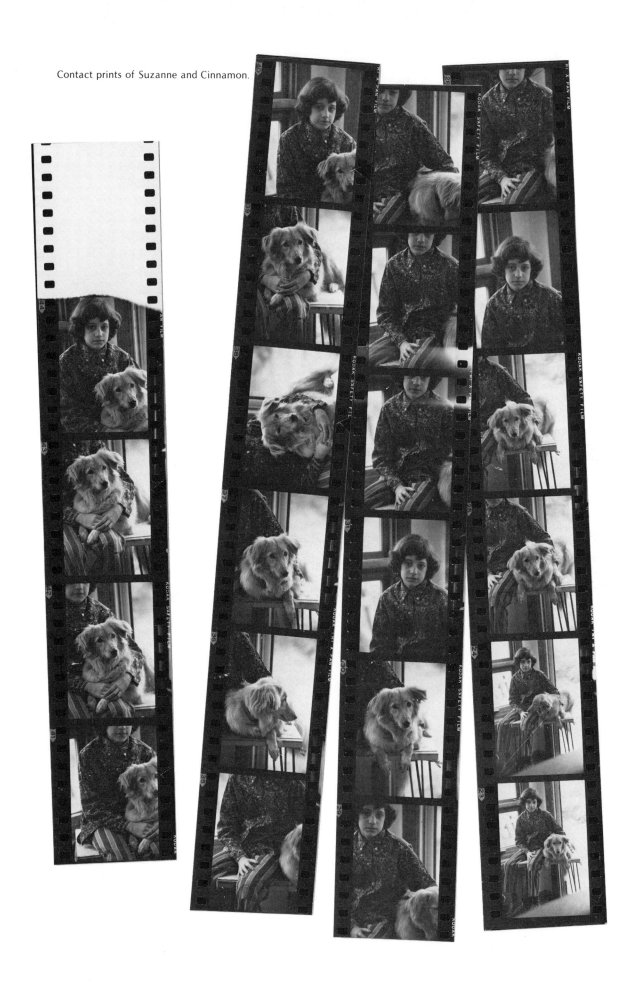

Contact prints of Suzanne and Cinnamon.

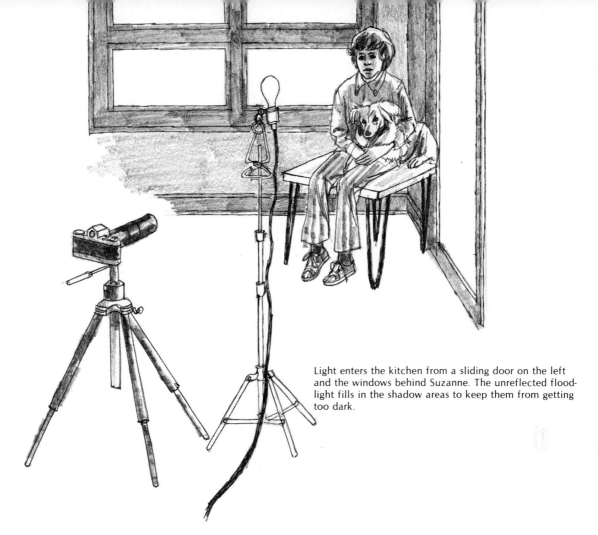

Light enters the kitchen from a sliding door on the left and the windows behind Suzanne. The unreflected flood-light fills in the shadow areas to keep them from getting too dark.

So that the lighting would be the same as the original inspiration, I decided to photograph Suzanne in the kitchen. The above diagram describes the set-up. I selected a small work table from the studio as a seat for Suzanne. Although the contrast between the areas in light and those in shadow didn't seem very great to the human eye, it was beyond the capacity of the film to record all the details in both successfully. To light up (it's called a fill-in) the shadow areas I introduced an unreflected floodlight -- for more on floodlights see pages 110, 112, and 113. The camera was a 35mm single lens reflex with a zoom lens. It's the very long lens pictured on pages 102 and 103. The focal length can be varied from 70mm to 230mm -- see pages 86 and 87. Because of its bulk and my intentions, the camera was mounted on a tripod. The film used was Tri-X rated at ASA 400 with an exposure of F 11 at 1/60 seconds -- see pages 100 and 101.

The shooting session started with the zoom lens at the 70mm position. At this focal length the entire figure was included. After two pictures, I concentrated on Cinnamon using the 150mm focal length. Finally, switching to the 230mm focal length, I stayed with it through the rest of the shooting session. As you can see in the contacts there were only two actions attempted. Notice that, except for the first two pictures, none of the others include the entire figures of Suzanne and Cinnamon. The reason for this is that the final print -- it's black and white film -- would be a mosaic of all the parts. I didn't have to take these parts in sequence since the actions changed very little, and the camera was in a fixed position.

After processing the film, I examined the negatives through a powerful magnifying glass. Those frames which seemed best for my purposes were notched with a scissors for easy identification in the darkroom.

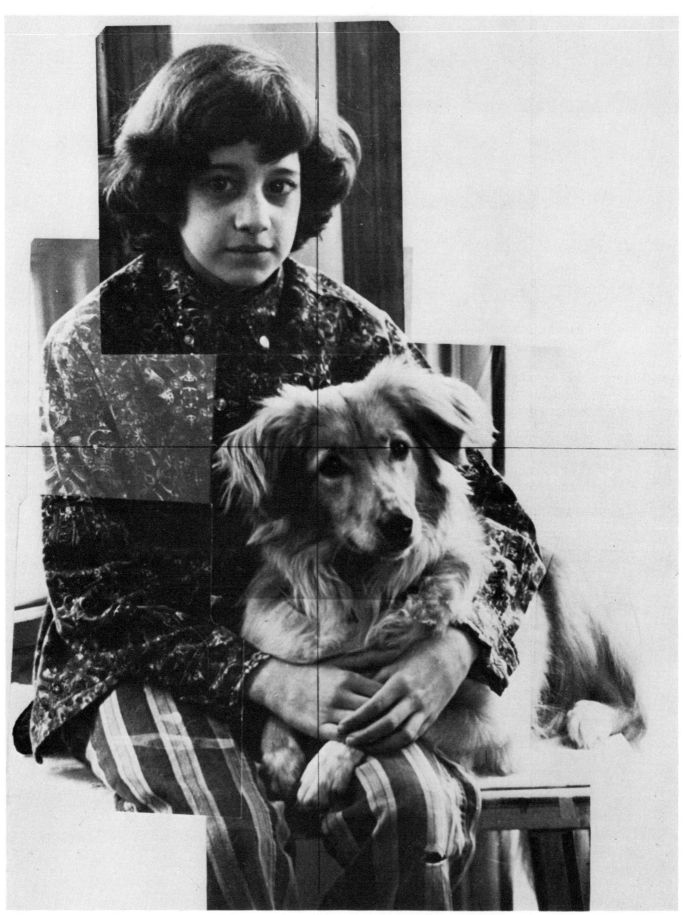

Separate photos enlarged to the same number of diameters were put together like a mosaic to produce a single large photo. Lines drawn through the middle are used as reference points when drawing.

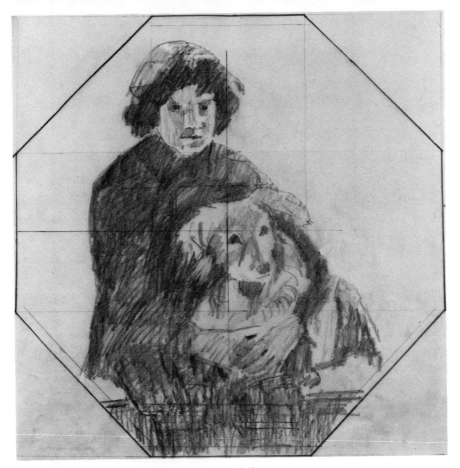

Tracing made of the photo in experimenting with the composition. The octagonal shape was my first choice.

All the photos received the same enlargement. I made one print lighter to see into better, but it was not an improvement over the others. It was, however, good enough to use. When dry, the white borders of the prints were trimmed off. Dri-mount tissue, which is very similar to the stuff used in iron-on patches, was tipped onto the back of each print with a warm iron. When the prints were aligned in the mosaic to my satisfaction on a sheet of illustration board, they were tacked into position with the warm iron. (A sheet of tracing paper was placed between the iron and the print to prevent marking or sticking.) Satisfied that nothing had moved while being tacked down, I put the mosaic into a dri-mount press for twenty seconds. A dri-mount press looks like the head of an alligator. The two ready lights function for its eyes. The hinged upper jaw heats up. When closed against the padded base it applies pressure as well as heat to the sandwiched-in tissue which melts and glues the print to the backing. A dri-mount press is convenient because I have one, but is not a necessity. The prints could as well be taped together onto a cardboard tacking.

Why the large print? I prefer to draw the subject rather than to use mechanical enlargement techniques. I'm also a believer in working at sight-size. This avoids the problem of adjusting all of the dimensions when attempting to draw something very large when what we see is very small. The finished mosaic was 21 inches high by 16 inches wide.

Since this was to be a very new approach for me, it seemed appropriate to give the painting a shape other than a rectangle. I placed the photo under a large sheet of tracing paper and roughly traced. I was more interested in the overall silhouette and value than in a careful outline. The first picture shape tried was an octagon, which was based on five cubes rather than with eight equal sides. It had an immediate appeal and I decided to use it. The photo was again slipped under the tracing paper, aligning it with the shape of the picture area. At the center of the octagon, where the horizontal and vertical lines intersect, I made a pin hole. Using a T-square and triangle I drew a horizontal and vertical ink line through that center pin hole on the photo. These would be the only guide lines.

Before starting the drawing I made the panel. It's described on page 64. Although I had originally planned to make the figure 42 inches high, the panel didn't allow for a figure any larger than 38 inches. At 42 inches the drawing would have been much easier since it would be exactly twice the size of the mosaic.

On a large sheet of paper I drew the intersecting horizontal and vertical lines which indicated the center of the painting and would function as my guide for the drawing. I drew two more horizontal lines 19 inches above and below the center point. These indicated the maximum size of the drawing.

With loosely drawn pencil lines -- I use office pencils and find the erasers on the end are just great -- I indicated the general shapes as they related to the guide lines. When a few places didn't seem quite right, I checked their accuracy by measuring with a ruler; then using a proportion scale, checked it with the photo. Simply put, the proportion scale is a dial within a dial. The smaller inside dial indicates the size of the original, 21 inches. The 21 inch mark was lined up with the 38 inch mark, the enlargement, on the outside dial. From that point on, any measurement read off the inside dial will have its corresponding enlargement opposite. Here's an example: 7 inches would be 13, 8 inches would be 14 3/4 inches.

As it turned out they were nearly right, but the checking gave me a greater feeling of confidence. From this point on, the drawing progressed nicely. The tones you see were not put in after the contours were established, but at the same time. It was essential, too, that a background value be established to describe the light areas and to help the illusion of depth and volume. The impression of the light striking the hair was especially important.

When the drawing was completed, it was traced onto the panel -- see next page -- using a 9H pencil (very hard) and a white transfer sheet which is normally used by etchers. The resulting white line was easy to see on the toned surface and didn't smudge. The 9H pencil didn't destroy the drawing in the process either.

With the aid of a proportion scale and the center guide lines, the large finished drawing was done on tracing paper, using regular office pencils.

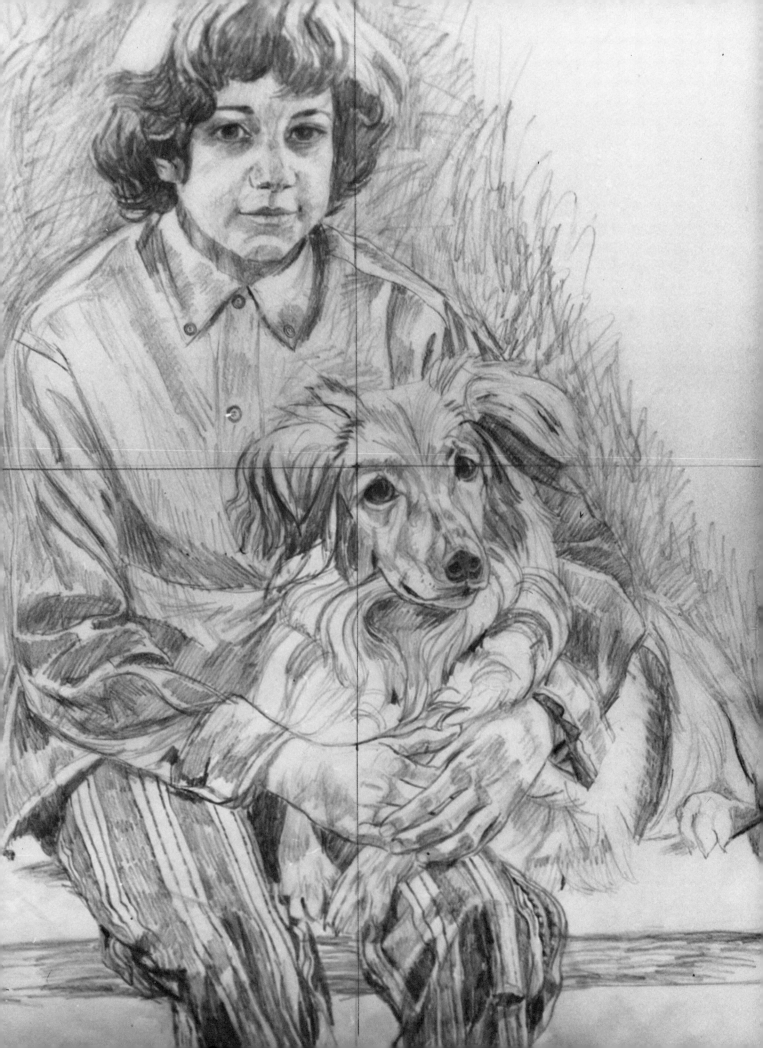

The concept of painting within a shaped panel requires framing suited to the times, a no-frame frame sort of thing. I've used a concept of a white border edged with moulding on other figure paintings which was well received. I prefer that the moulding be put on before the painting is started.

The panel was to be cut from a 48 inch square piece of 1/4 inch Masonite. Four small triangles were cut from each corner. The bases of the triangles were an inch shorter than the remaining edges of the square. This produced an octagon with the diagonals shorter than the horizontal and vertical edges. It was done this way because the sides appeared more equal than when they were equal.

I glued one by three inch supporting strips to the back edges. Cap moulding was cut to fit and then nailed to the supporting strips. I used a protractor to determine the angle of each cut -- they were not all the same because of the unequal length of the sides -- to assure a perfect fit. I've forgotten the angles but one was something like 67 1/2 degrees. When it was completely assembled, I gave the entire panel, frame and all, three coats of polymer gesso.

A line two inches from the moulding was drawn completely around the panel to form the border. I put Scotch tape down along its edge. Pieces of bristol board slightly narrower than the border were rubber cemented over the tape to produce a tight-fitting mask. The edges of the panel were wrapped with kraft paper -- see the photo on page 69. When the painting was finished I'd need only to remove the mask and it would be ready for exhibiting.

To establish the pointillist effect early in the painting it was decided to spray the background. Not long before this I had purchased an inexpensive spray outfit (less than fifty dollars), which consisted of a small compressor and three different-sized spray guns. I used the smallest of these, which produced a relatively fine spray and was labeled *shading brush*. As air passes through the gun the spray is regulated by placing a finger over a hole on top. When the finger is lifted the spray stops. I discovered that by tapping my finger on the hole it spattered. A number of different colors of similar value were spattered on until the background was completely covered. I then traced the drawing on top of it.

The key value in the lay-in was the dark of Suzanne's hair. I painted this first, followed by the lights in her hair and face. The lightest value on her left side was established next, then the light on her right side. At this stage the middle value areas on the front of her face were represented by the background color. Her eyes, eyebrows, lips, the dark under her nose, the nostrils, and the folds of her cheek were then painted. A thin wash of a medium value flesh tone was applied over the entire front of her face to pull all the values together. The light and dark areas, which included drawing the folds of the shirt, were painted next without concern for the pattern of the cloth.

I made no attempt to draw the pattern of the shirt in pencil because it would have confused more than helped me. I would paint it in using the shirt as my guide. A careful study showed that the pattern was made up of series of various rectangular sizes and shapes in which variations of only a few different designs were repeated. These rectangular shapes were drawn in with a black line to conform to the folds in the material. The design in each was painted completely before moving to the next one. It proved to be a little tedious, but frequent short breaks kept me fresh. Because the paint for the lay-in of the pattern was thin it didn't obscure the folds painted in earlier.

The background was sprayed on with an airbrush. The spatter-like effect was achieved by tapping the air valve with my finger while spraying.

The partially completed lay-in, showing unfinished portions which still exist as white lines.

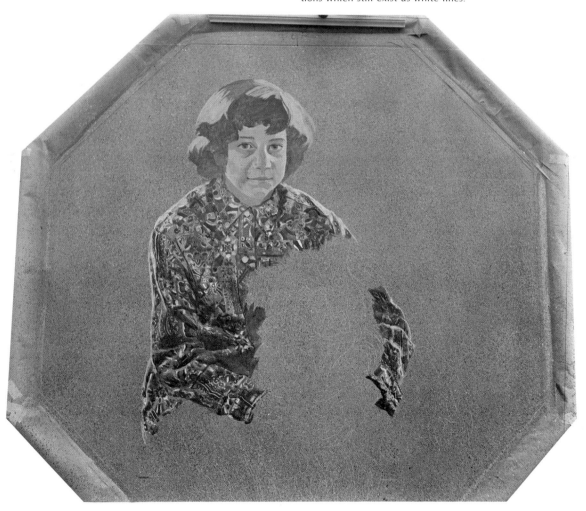

In much the same fashion as described earlier, the lay-in for Cinnamon was completed next. Notice how broadly I handled the lay-in. There's enough information to describe the subject and to describe its relation to the surroundings with but little degree of finish. Although the color and relationship of Cinnamon to Suzanne's shirt was satisfactory, the dog's head didn't seem quite right. It was either lopsided, too long, or both. Since this was just a lay-in I moved on to the hands. I'd resolve the dog's head later.

The hands were keyed a little lower than the flesh of the face, because I wasn't sure at that time just how light or dark they would eventually be. With acrylics it's easier to make something lighter than darker, while retaining the character of the painting. I painted the slacks, too, darker than they would appear in the finish. This was done deliberately because later, when the dots were introduced, the contrast would produce an interesting texture.

It wasn't until I reached this stage that I gave any thought whatever to the bench that Suzanne was sitting on. I remembered an old bench my grandfather had in his backyard. It was lumpy where old paint had peeled, been scraped off, then painted over. As a child I often wondered how it could always appear freshly painted and shiny, yet show so much wear. It was green, so I painted this bench green too. However, the results were less than promising. I'd save that for later, but in the meantime it dawned on me what was the matter with Cinnamon's head; the muzzle was too long.

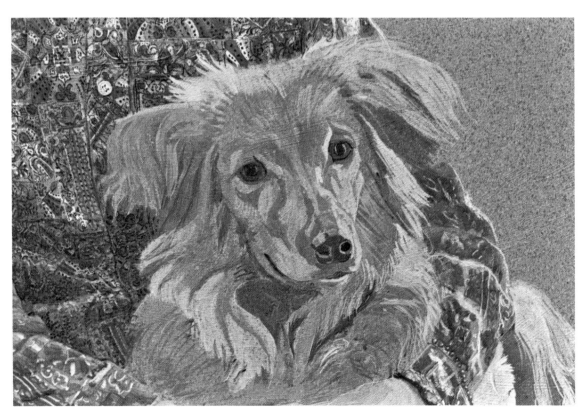

The lay-in of Cinnamon.

The head is nearly complete, as is a portion of Suzanne's shirt. These completed areas are handled in a pointillist technique, while the rest of the lay-in is rendered as washes.

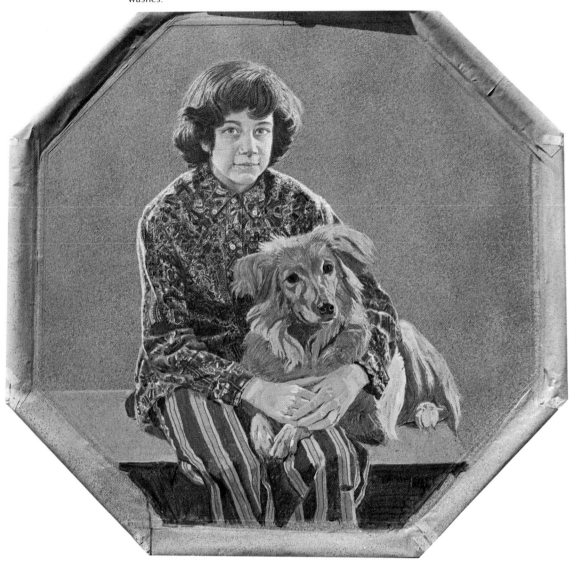

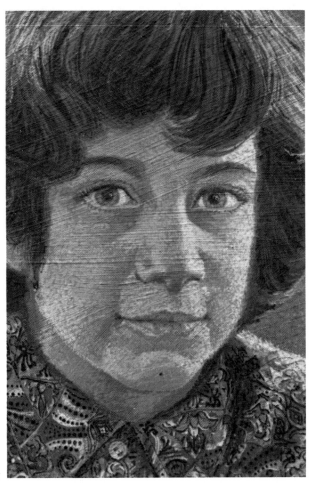

Close-up of the face, showing pointillist technique.

Palette with 35mm photo film containers which hold an assortment of pre-mixed colors. These are for the shirt.

On page 66 you might have noticed that some more work had been done on Suzanne's head and shirt. The above closeup describes the head at this stage. As mentioned earlier in the cemetary painting, the major problem with acrylic is that it dries to a different color and value than it appears when wet. This can be an even greater problem when one attempts to be a pointillist. I've read somewhere that the famous pointillist, George Seurat, was surrounded with pots of paint as he worked. On several occasions I had stored white acrylic in empty plastic 35mm film containers for long periods of time with no adverse effect on the consistency. It seemed like a logical next step to mix an entire series of flesh tones using the lay-in for a guide, and to store them in the containers.

did that and added a few more. It was one of the best decisions I've ever made; the colors are still as fresh as when I mixed them. For a label I simply painted the cap with the color inside.

I started painting the head using fairly large dots. By doing this I hoped to establish an appearance of finish without getting finished. It was very important at this stage to keep the head and painting fresh looking. Later, when I was closer to the character and likeness that I desired, the dots would be made smaller as the subtleties were introduced. The brush used for this was a long handled number 6 round red sable which is generally used for oils.

The same procedure for premixing and storing the paint that I followed for the head was also used for the shirt. Even

Close-up of the shirt, showing individual designs within the pattern.

This was my working arrangement. The sides of the panel are masked to keep them clean. The shirt served as the model for the pattern instead of the photos.

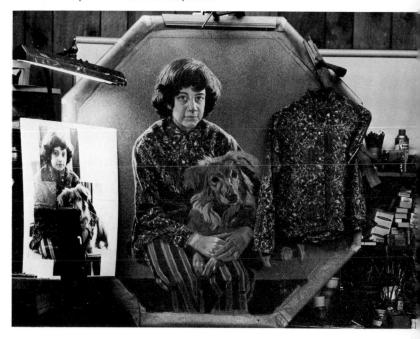

though the pattern in the shirt was so well established in the lay-in that I could paint in all the reds, then the blues, etc., I didn't. Greater control and patience would be required were I to finish each design completely before moving on to the next. The key to each design was the black line which was not included in the lay-in for the obvious reason that I'd either have to paint around it or paint it again. When added to each pattern it marked that one complete.

The photo on the right shows my working arrangement. The two C-clamps were used, when not holding the shirt, as rests for my mahl stick. To avoid making marks on the frame a piece of wood was included between C-clamp and panel. Most of the painting is done standing up but once in a while I prop myself against the high stool.

This is the finished painting. The paint for Cinnamon was mixed and stored in 35mm photo containers as I had done for the other areas. It should be mentioned that I kept a palette of fresh colors on hand to mix variations I'd not anticipated earlier. Whereas this palette was used sparingly in the shirt pattern and a bit more for stage two in Suzanne's head, it was used quite often when paintng Cinnamon.

By spacing the dots a little further apart on the slacks I was able to establish the interesting texture I'd anticipated, while producing even the most subtle wrinkles with little effort. Perhaps I had also become more accustomed to the approach.

With Cinnamon and the slacks finished. I decided that the hands should be generally as light in value as Sue's face. I then received a pleasant surprise. The cool grayer flesh tones of the lay-in produced an attractive transparent quality to the flesh. As a result it was a question of how little to do rather than how much. On several occasions after an area on the hand had been successfully completed I'd catch myself adding the same note to the face. It wasn't long before I had switched to the face completely.This time with a small number 3 oil sable, I started the refinements. I often dipped into the palette for slightly different variations, especially the red. Edges were softened. The lower lid of her left eye was adjusted so that it turned in space instead of just up. I added to the tip of the nose, to her lips, and to her hair as well. The freckles were the last things put in. While working on the head the same notes were made in the hands, with the result that both were completed together.

But the green bench was still there. It shouldn't be green but natural brown in color. A wash of burnt umber was floated over the green. The wood grain was invented and, like the rest of the painting, made more decorative than real. The painting was finished. I removed the wrappings and the masks. There were no blemishes to spoil the white surface.

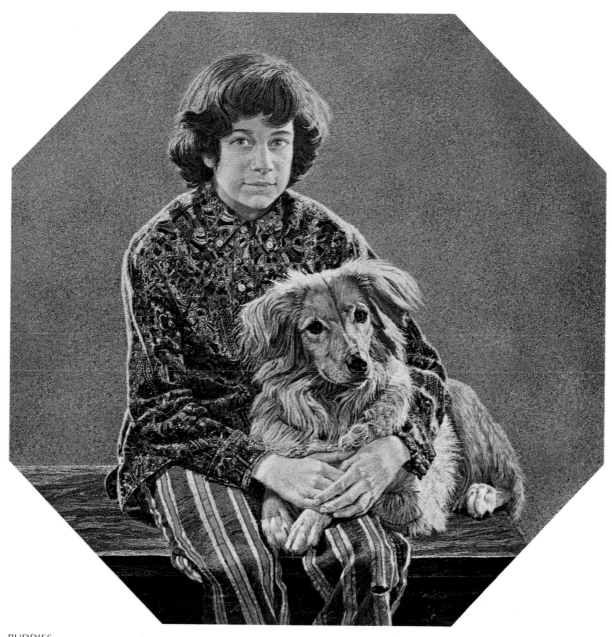

BUDDIES

CHAPTER 7
THROUGH OTHER EYES

SUSAN SWAN

As is obvious I wasn't particularly literal in my interpretation of this photo. It served only as a reminder of the locale and the feeling I had there. I usually do a couple of thumbnails to work out the pattern of shapes and light and dark areas. Once I get into the painting itself, I very often ignore the sketch and the photo all together.

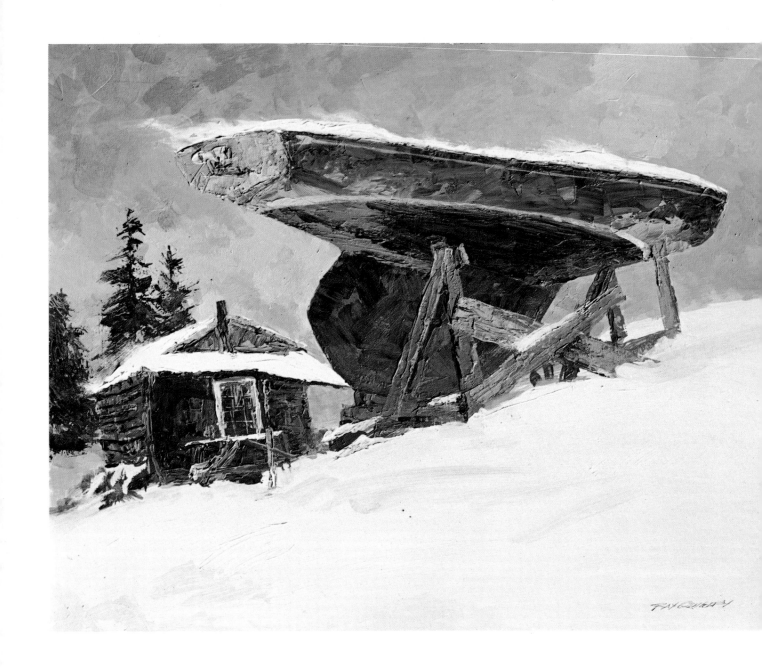

RAY QUIGLEY

The key word is *select*. Make many thumbnail sketches. Use your reference; make sure that it doesn't use you. Arrange the various elements to suit your needs. Experiment by moving these objects from your photographs left and right, up and down or back into your picture. The fun is in creating your own interpretations.

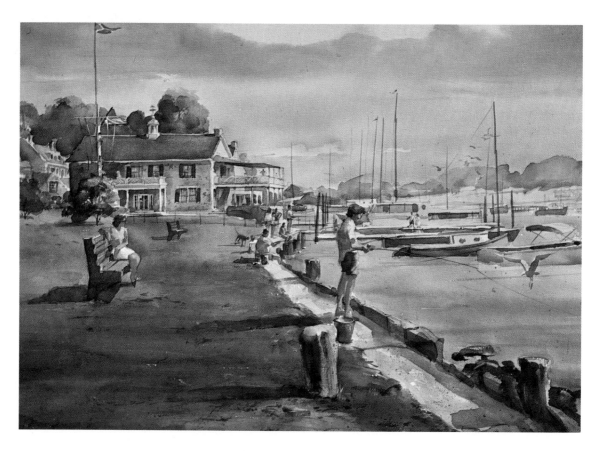

JOHN LAWN

I'm not afraid to make a literal interpretation of photographs when I use them, although I seldom do. Most of my work is linear and drawn from my imagination.

This is a local landmark and I felt that the painting should be a faithful representation.

When a subject interests me I determine its merits by painting a rather comprehensive sketch. This is placed on an easel for evaluation until I decide whether it's worth doing larger. As so often happens in watercolor the finished painting may lack some of the freshness of the sketch, but solves many of the little unhappinesses.

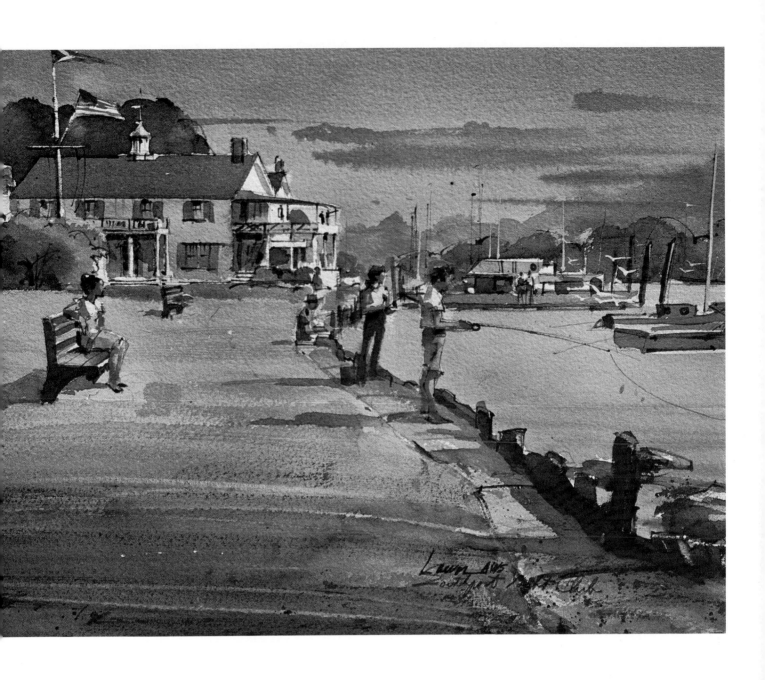

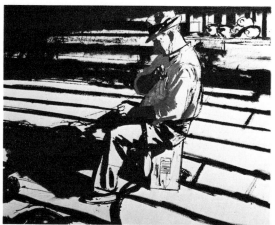

CHARLES SOVEK

I like to start my paintings with a strong ink drawing, done with a brush. This enables me to lay-in my whole picture with paint and still be able to pick up my drawing if needed.

With medium-to-large bristle brushes I mass in all of the shadows. Then the lights are added by working boldly, avoiding fussy detail. I now have a simplified version of how the painting will look finished.

I start working back into my shadows, striving for exact color and values. Notice how I'll let the shadows go beyond the drawing -- working from inside the forms out and cutting back with the lights. I'm always drawing like this, with my brush, rather than neatly filling-in areas. At this point I like to stand back and look at the painting. Some areas are finished; others need a great deal more detail, the head and hands for example.

This is the time for pulling the whole picture together. I work over the entire painting, tying in here, subordinating there, working for an accurate statement of color, values and *LIFE,* which, for me, painting is all about.

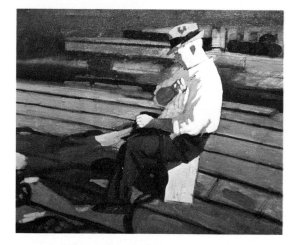

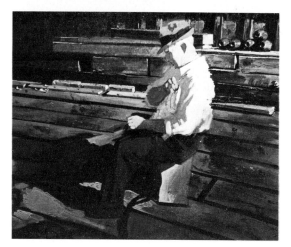

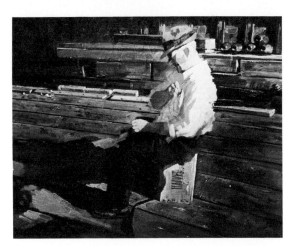

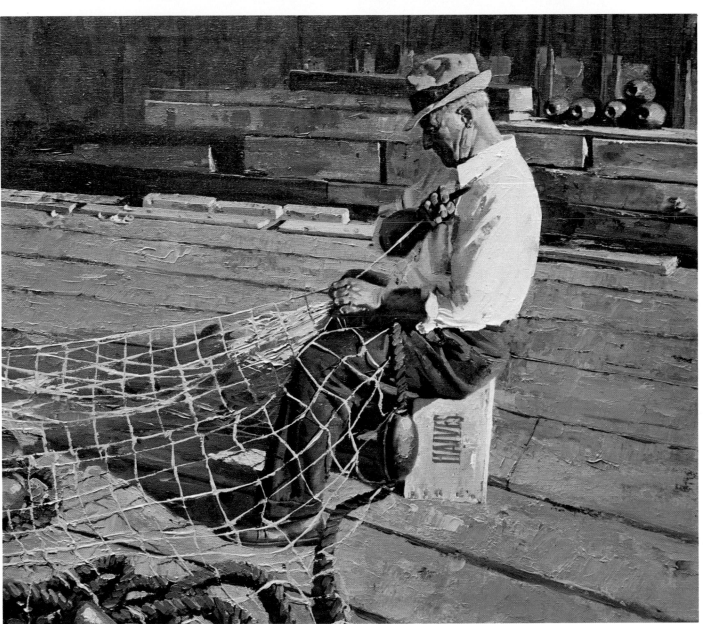

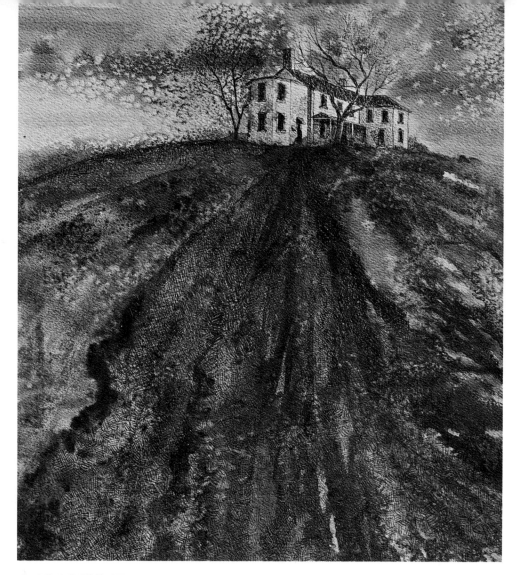

MYSELF

In the early 1960's my thinking was much different than it is today. When I first discovered the old mansion discussed in the introduction, it inspired me as much as any of my students. In those days I preferred paint action to literal interpretation but the image had to be recognizable. My idea was to show the vitality of the building escaping into the atmosphere as it decayed.

Watercolor was used. Salt was shaken onto wet paint to produce a controlled textural effect emanating from the building and was used on the driveway as well. The painting was finished by drawing into the watercolor with pen and sepia ink. This retained the freshness while making the whole more descriptive.

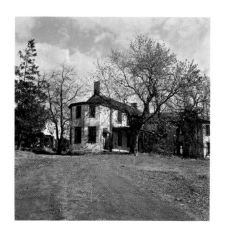

CHAPTER 8
THE CAMERA AND FILM

When I was first introduced to photography, my friend and instructor, Ed Slattery, a fellow illustrator, drilled into me the importance of proper exposure and sharpness. Ed was exasperated with me because it took a long time before I could tell the difference between sharp and really sharp. Unfortunately, there were never two photos exactly alike for comparison.

For a picture to be sharp it must be taken with a good lens. More important than that, there must be a provision built into the camera for focusing the lens.

Since exposure is dependent upon the camera's ability to let in or keep out light as needed, it must have a variable diaphragm. Exposure is also determined by the length of time the light is permitted to strike the film so the camera must have a variable shutter as well. Only cameras manufactured for the advanced amateur and professional fall into this category. I therefore, do not recommend any camera for the artist's use without the above features. Although the Polaroid camera does fit into the above category, its primary advantage is for someone who needs a picture in a hurry; otherwise, it produces small prints with a cost per shot far in excess of the cameras covered in this chapter.

Since camera styles and features change as often as cars, there's plenty of good used equipment around. Of the five cameras I own, two were purchased used. These have performed as well, if not better, than those purchased new. All equipment sold through a reputable camera dealer is guaranteed, so an excellent used camera, which costs a great deal new, can be purchased for a lot less.

Good lens
focus adjustment
variable diaphragm

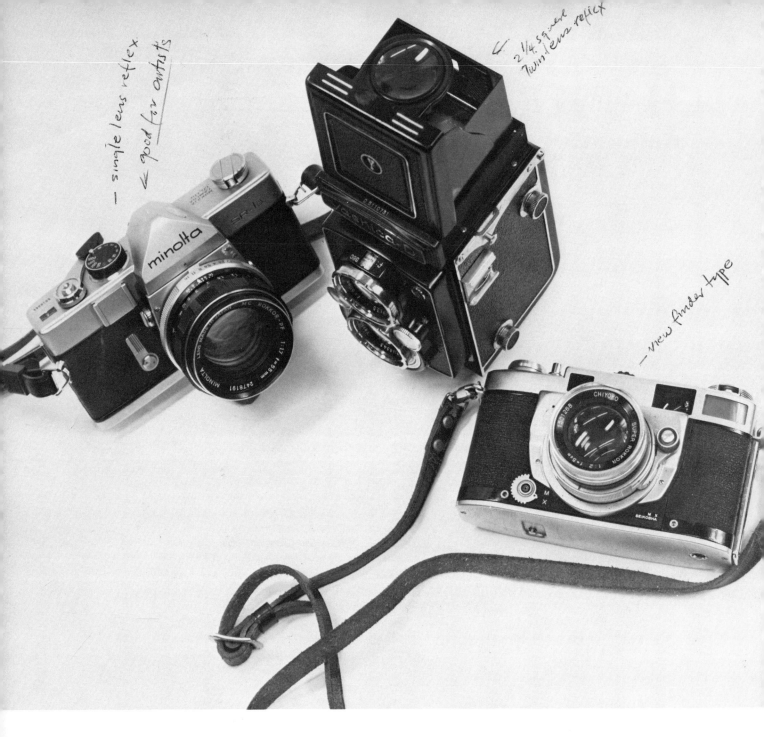

The cameras above illustrate the three different types used most often by the serious amateur, the artist and the professional. Of the three cameras, two are 35mm and the other, bigger camera in the middle is a 2 1/4 square, twin-lens reflex. With this camera, the two matched lenses have separate functions. The top one is the viewing lens which reflects the image to be taken onto a ground glass. The negative or slide produced by this camera is as big as the ground glass viewer, 2 1/4 inches square. This is nearly twice the size of that produced by the 35mm camera. With the square format, composing is simpler because the subject will always fit, be it vertical or horizontal. You will find some of the finest lenses made, along with the most dependable and efficient shutters in this kind of camera. Film advance is either fully

Above. The 35mm slide can be used as either a horizontal or a vertical picture.

The square format of 120 film slides function the same for both horizontal and vertical compositions.

automatic or semi-automatic -- the film advance and the cocking of the shutter are two separate functions on the semi-automatic -- depending on the model. It's possible to double expose the film on the semi-automatic model if you were to forget to advance the film after each exposure. This camera accepts 120 film which gives 12 pictures to the roll. The price range is moderate to expensive.

The 35mm camera on the right is of the viewfinder type. With a viewing system that's always bright, this camera is the easiest to use. It accepts film fed from a magazine with either 20 or 36 exposures to the roll. Film advance is always automatic -- as the film is advanced the shutter is cocked automatically. It's nearly impossible to double expose with this type of camera. When the end of the roll is reached, the film must be rewound into the magazine before it is removed, otherwise it's exposed to the light and ruined.

This is a moderately priced camera with lots of good buys, especially when purchased used. It has recently become popular with manufacturers of the viewfinder camera to incorporate what they call fully automatic exposure. Actually, it's not completely automated. With this feature, you must

select either the shutter speed or F stop. Most often it's the shutter speed. The electric eye then selects the proper F stop. These cameras also include an override system which permits manual operation. With these features the cameras are not cheap and might not be worth the extra cost to the artist, although it makes for a very handy camera for general use.

The camera on the left is a single lens reflex. It's very similar to the viewfinder camera in every feature but one: the viewing system. With this camera you view the subject through the taking lens. When the shutter is released, the mirror, by which you're able to see the subject, flips up out of the way during the exposure, then drops down again. This action is so quick and smooth that you're not aware that it happened except for the noise. Yes, it is a bit noisy. The image seen through the lens is not as bright as in the viewfinder type. It will also vary according to the diameter of the front or light-gathering element of the lens. This is measured in terms of F numbers which you will better understand after reading page 100. Simply put, the lower the F number the better are its light gathering qualities. For instance, an F 1.9 lens has better light gathering qualities than F 2.8. The biggest advantage of the single lens reflex is that it can grow with your interest and needs because it accepts lenses of different focal lengths -- see pages 86 and 87. Unfortunately it can be expensive, but there are some great buys in the unmetered, used category.

The twin lens reflex definitely has the best viewing system for composing the picture. The image can be seen with both eyes open, except when focusing. With the 35mm cameras only one eye can be used. It's even an excellent unobtrusive camera in spite of its size. By facing in one direction and pointing the camera in another, no one is aware that you're not shooting in the direction you're facing.

There are two drawbacks to this excellent viewing system, the most important of which is image brightness. The light gathering element on a twin lens reflex is generally F 3.2 which isn't very bright. Most twin lens reflex come equipped with an image brightening fresnel screen. This helps. Were the viewing system used expressly for composing it would have no equal, but you must focus the image there as well. There's a small magnifying glass attached to the hood. This enlarges the image to make focusing easier, which is generally accomplished by turning a large knob on the side of the camera. During the focusing operation the entire front section moves forward or back. When the knob is turned to the closest focusing position the front section is fully forward. At infinity it's retracted fully.

The second difficulty with the viewing system of the twin lens reflex is that the image is reversed. To follow action the camera must be moved in the direction opposite to that on the ground glass.

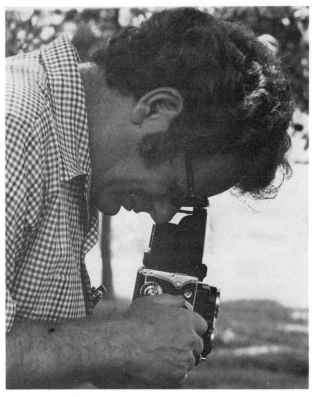

The camera is held close to the face. The focusing magnifier is in the raised position for critical focus.

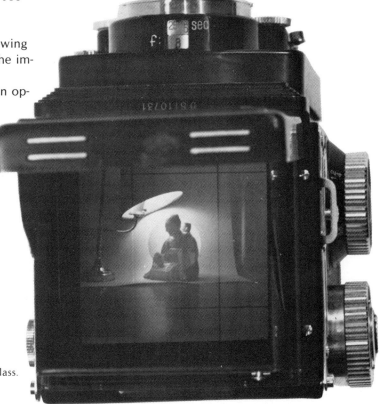

The focused image on the ground glass.

The camera is in focus when the bottom image in the circle is lined up with the top portion.

With most 35mm cameras the viewfinder is the easiest to use and an accurate indicator of what is being reproduced on film except when very close. Within six feet the angle of difference between the viewfinder and the lens increases as the distance to the subject decreases. This is called parallax. Usually when the camera is focused to its closest distance, approximately three feet, the viewfinder is no longer an accurate indicator of what's being recorded.

This is especially regretable because this is portrait distance. In the examples below, the center photo describes what might be seen through the viewfinder at this distance, while the two outer photos more closely describe what's actually being recorded. The differences in these two photos result from the subject being in a position lower than the lens on the left and higher on the right. It's important to note, however, that in all the years I have used a viewfinder camera, I have never failed to get on film the image that I saw. Once, though, I shot an entire roll, 36 exposures, only to discover that I had forgotten to remove the lens cap. I never made that mistake again. Once is enough.

Not only is the image bright on the viewfinder camera but the rangefinder is the quickest, easiest, simplest and most effective way to focus it. Most viewfinder 35's are equipped with rangefinder focusing. When looking through the viewfinder the rangefinder image is generally confined to a circle in the center. It's sometimes tinted a color; mine is pink. Within this circle the image is split into two parts. When the images are aligned, the camera is in focus. The viewfinder/rangefinder camera works well in poor light where the reflexes encounter the most difficulty. If the viewfinder/rangefinder camera has any shortcomings it's that you're limited to just the single 50mm lens.

The center image is what you see through the viewfinder, but parallax can put the subject close to the frame and higher (left photo) or lower (right photo.)

50mm

105mm

most artist use this

The single-lens reflex is slightly bigger and bulkier than the viewfinder camera. An advantage over the viewfinder camera lies in the fact that the image you see through the lens is the image recorded on film. Because of this, the minimum focusing distance is about two feet closer than with the viewfinder camera.

Although focusing the single-lens reflex is a bit more difficult than with a rangefinder, it's better than the ground glass of the twin lens reflex. It, too, uses ground glass focusing; but there are assisting features like very bright fresnel screens and, on mine, the center portion ripples until it is in focus.

The biggest advantage of the single-lens reflex is the feature of interchangeable lenses. This means that lenses of different focal length can be used. The focal length of a lens is that distance from the center of the lens -- the area where the diaphragm is located -- and the film plane when the lens is focused at infinity. The longer the focal length the narrower the angle of view. Put simply...the longer the focal length the greater the telephoto effect. I took these four uncropped photos from the same position. I used one single-lens camera with three different lenses. In the first photo a

150mm

230mm

normal or 50mm lens was used. It was
replaced by a 105mm telephoto which in
turn was replaced by a zoom lens set first at
150mm and then 230mm. It's easy to see
how this one feature makes a single-lens
reflex body into a multi-purpose tool.

The principle development which has
brought the single lens reflex to its current
popularity is the *automatic* feature. It's
natural to assume I'm referring to the same
feature mentioned earlier in the discussion
of the viewfinder camera. Although the
single lens reflex has built-in metering
systems, which I discuss on pages 100 and
101, I'm referring to the feature which per-
mits focusing with the diaphragm in its
wide open position and stops down to the
proper F stop when the shutter is tripped.
Look for the word *automatic* on any
telephoto lens you might purchase because
there are a lot of older manual types around.

The single-lens reflex is an excellent
copy camera. Because of the framing ac-
curacy, paintings to be photographed can
be cropped as desired. When projected,
paintings sometimes take on a quality that
enhances the original. Slides are often used
for presentations to galleries and prospec-
tive clients at times when it's not possible
to show the originals.

Most people think of film in terms of the paper-backed roll. With the trend toward the smaller, more automated cameras it's being gradually replaced with magazines and cartridge packaged film. The twin lens reflex uses 120, a paper-backed roll film. With the movement toward the mass market smaller format, the 120 size is produced in more limited quantities and labeled *professional*. There needn't be any fear of its being discontinued, because the 120 format is in great demand with the professional photographer and will be for some time to come. What the tag, professional, really means is that the film is no longer sold in single roll but in multiple roll packages. When stored in the refrigerator, film keeps for long periods. If kept in the freezer it will keep even longer.

Although all the major film manufacturers produce film for this size, there are exceptions, principally Kodachrome, an excellent color film, which I prefer. Ektachrome is an excellent substitute, however. The major difference between the two films is in the processing. Whereas Kodachrome is processed only by laboratories licensed by Kodak, Ektachrome can be processed by anyone, even the artist in the home darkroom. Kits for processing Ektachrome can be purchased in most camera stores. Although the processing of film is not covered in this book, I can offer a small tidbit of information that might be of value. Packaged with each Ektachrome processing kit is a chart which describe the steps involved with the times and temperatures for each step. In the first step the temperature is very critical, it must be 76 degrees. If the temperature should fall below 75 1/2 degrees, the finished slide will have a greenish cast. Should the temperature rise above 76 1/2 degrees the resulting slides will be pinkish. Since such control was difficult to impossible in my rather primitive setup, I reasoned that if during the processing the temperature was both below and above the critical points they'd cancel each other out. The experiments -- more than one – were a complete success. There was no trace of either the green or pink in the slides.

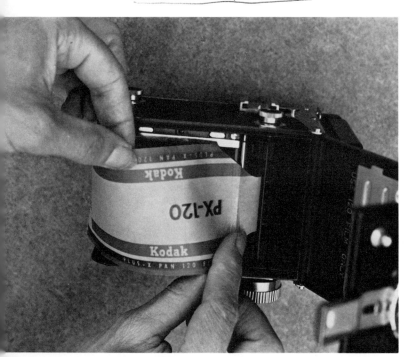

In the camera pictured here the film is placed in the lower well, after breaking the seal. The notched end is fitted into the slot in the take-up spool in the upper well.

The film is then advanced by turning the film advance knob until the red arrows on the film line up with the arrows on the camera.

Turn the film advance knob until it stops. The number 1 will appear in the film counter window (the small ring directly above the focusing knob and directly across from the film advance knob.) See arrow.

The serrated wheels on each side are turned to adjust the F stop (8) and shutter speed (125).

On the twin-lens reflex camera it doesn't matter whether the film advance mechanism is fully automatic or semiautomatic, the film counter always turns to *start* when the back is opened. Generally the film advances from top to bottom on the automatic cameras and bottom to top in the semiautomatic varieties. In either case the empty spool remaining in the camera will indicate the location for the film roll. Start by removing the empty spool and replace it with the roll of film, the seal unbroken, then the empty spool is put in the opposite end.

Break the seal. Pull the paper forward. Slip the end of the paper into the slot of the empty spool. It's important that the yellow back of the paper is facing you. If the black side is showing you've put the film in backward. Turn it around.

When the paper is positioned in the slot, turn the film advance knob -- or crank, on the fully automatic models -- and begin rolling the paper onto the spool. The camera pictured in the demonstration is of the semiautomatic type. Continue advancing the film until a broad arrow appears. When this arrow is directly opposite the arrow on the camera body, the back of the camera should be closed and locked. Before moving on, note the needle-like projection near the arrows on the back of the camera. This is the device which trips the automatic *start*

mechanism when the camera is opened.

Turn the knob or crank until it stops. The number 1 will appear in the window. On the semiautomatic camera the film cannot be advanced again until the button at the center of the film advance knob is pushed. It can be turned, then, until it stops at number 2. On the fully automatic model, the film cannot be advanced until the picture has been taken. After taking picture number 12, the film knob and/or crank can be turned freely. Continue turning until you're sure that all the film has been wound onto the take-up spool.

The controls for adjusting the F stop and shutter are located at the serrated wheels situated between the lenses. The F stop and shutter speed are viewed through a small opening in the top.

The popularity of the 35mm format has led to considerable distribution. The film can be purchased almost anywhere. When you purchase the film, get the prepaid processing mailer as well. When the roll is finished it can be mailed at your convenience. The processed film will then be mailed directly to your home. When Kodak film is purchased outside the United States, the package will also include a processing mailer. Some other film manufacturers in the U.S. do include a processing mailer with the purchase price.

As a believer in the one film concept I stay with Kodachrome 25 almost exclusively, although there seems to be little difference between it and the faster version, Kodachrome 64. My choice has been based on availability and the consistency of the processing. Your choice should be made only after experimenting with other films until you find the one which best suits your needs.

35mm color transparency film is the best buy in film. It's cheaper per shot than color print film. In addition, it can be projected to a size which makes viewing the next best thing to being there. Color transparencies are practically grainless. The images appear sharp even when blown up to wall size. Color transparency is also a best buy because of the special sales. Most of the color film I purchase is picked up at sales.

Since 35mm film is packaged in magazines, it can be produced in any lengths from just a few frames to 36 frames. It's sold in individual packages of 20 or 36 exposures but if the film is purchased in bulk, 100 foot lengths, it can be rolled to any number of exposures desired. This is what I do. I store labeled magazines of 10, 18, 24, and 36 exposure lengths in the refrigerator. An inexpensive daylight film loader is used. The number of turns on the crank handle dictate the number of exposures. Of course, only black and white film is purchased this way. It would be difficult to find a color processer that handles such varied lengths.

Snap-cap magazines are sold in boxes of ten. These have been made especially for the people who roll their own. Unlike the

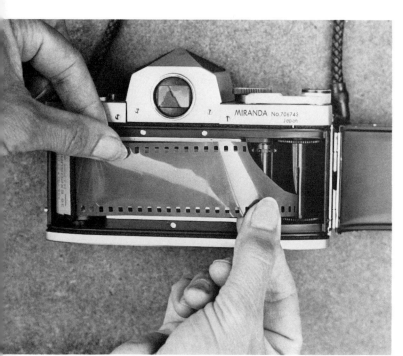

Film is placed in left hand well with the head of the spool facing down. Pull the notched end across the body to the right hand well. Fit notch carefully into the slot of the take-up spool.

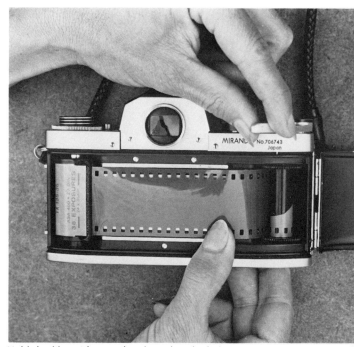

Hold the film with your thumb so that the holes engage with the sprocket wheel.

Slowly push the film advance lever until the entire length of the notched area is around the take-up spool and the holes on both sides of the film are in contact with the sprocket wheel.

Close the back. Release the shutter and advance the film, twice, or until the counting indicator is at "S" or "O". See arrow.

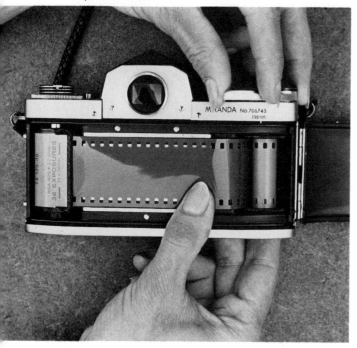

regular magazines, these can be reused often. The ten that I have are several years old and have been reused often with no fogging or light leaks. Should you prefer to paint from black-and-white photos as many artists do, then film purchased in bulk is a good buy. In Chapter 11, the process for making black and white transparencies is described in detail.

To load the camera open the back which will automatically set the film counter at zero. On one side of the camera is a well. On the other side there's a geared take-up spool. Place the film into this well with the longer tip on the bottom. The knob above the well must be pulled up to allow its entry. When pushed back down, the grooved end of the projecting rod engages with a bar located inside the center spool of the magazine.

By holding the film anyway that's convenient, pull it across the back of the camera, then thread it into the take-up spool. Here's where the difficulty occurs. The film must engage onto the spool as the spool is turned. In most new 35 mm's the film is pulled under rather than over the spool. Pulling the film under the take-up spool in this way assures that the sprocket holes will be fully engaged with the take-up gears. However, the film tends to slip out unless held carefully.

Using the film advance lever, pull the film forward until the geared wheels on both sides engage with the sprocket holes. Chances are the lever must be advanced until it stops. Release the shutter and advance the lever again until it stops. Use your thumb to make sure that the film is fully engaged on the sprocket holes and take-up spool. Close the back. Release the shutter and advance the film again. Release the shutter again. From this point on you're ready to take pictures. After 20 or 36 exposures, depending on the length of the roll, the film advance mechanism will no longer advance. This indicates that the end of the roll has been reached. Should this occur in the middle of a roll do not force it. The film is jammed. Rewind it and start with a fresh roll. As you advance the film it's a good idea to watch the take-up knob. If it turns you'll know that the film is advancing. When all the exposures have been made the film must be rewound into the magazine. To do so, push the rewind knob - there's usually a fold-away crank handle to speed the process - until there's no longer any pressure. The film has been rewound into the magazine. The camera back can be opened.

The shutter speed indicator is usually located on a wheel situated at the top of the camera. The F stop changes are made by twisting a ring on the lens.

CHAPTER 9
VIEWING THE SLIDES

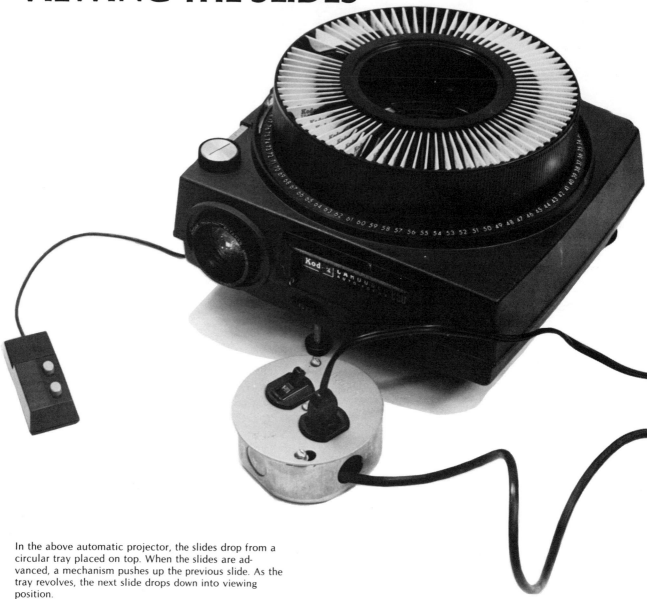

In the above automatic projector, the slides drop from a circular tray placed on top. When the slides are advanced, a mechanism pushes up the previous slide. As the tray revolves, the next slide drops down into viewing position.

It's natural to assume that, after the selection and purchase of a camera, the first order of business is to learn how to use it. However for the artist the camera is part of a system, which also includes the film and a method for viewing the finished product.

Because of the limitations of print film in both color and black and white, the emphasis first will be on how to view the resulting transparencies. In fact, the viewing method selected can affect the approach to taking the pictures.

The tray is placed on its side with this automatic projector. The slides are pushed into, and removed from, viewing position with the push-pull action of a rod.

There are projectors available for both the 120 and 35mm formats. Again, because of the trend toward the smaller format, there is a wider selection of 35mm projectors to choose from. These vary considerably in style but most offer a 500-watt projection lamp and a system for handling a number of slides. Most of these projectors come equipped with an F 2.8 lens, but you might find that the projector of your choice has either a faster F 2 or slower, F 3.5 lens. Remember that the light gathering qualities are dependent on the diameter of the front lens. The same applies to the projection lens. The greater the diameter of the front element, the more light it will transmit. It would be a better choice, therefore, to pick the F 2 lens over the F 2.8 and a third choice would be the F 3.5.

There are basically two different types of projectors: fed from the side or dropped from above. Both accept circular trays which hold from 80 to 140 slides. The side-fed projector will also accept transparencies placed in oblong 36 slide trays. The photo on the left shows the gravity-fed while the above projector is side-fed.

Another important feature to consider is remote control. With the viewing system that I recommend you'll be closer to the screen than to the projector. With remote control the series of slides can be changed, in either a forward or backward sequence. Some remote control devices also include provisions for focusing. The additional cost over the manually operated projector is comparatively small. An additional remote feature to consider is an extension cord with a switch. You'll find that this feature has many uses which will be discussed in this and the next two chapters. I have two switched extension cords which were made especially for this purpose. Electrical supply stores have a number of varieties which contain fuses so that there's never a fear of overloading a circuit.

With the present popularity of the smaller format the 120 projectors are hard to find. Most of these, like the one pictured below, accept but one slide at a time. I'm sure, though, that if you look hard enough you'll find one to suit your needs. If not there can always be a switch to super-slides -- see pages 97 and 98.

This projector accepts both 2 1/4 and 35mm slide mounts. However, it's not automatic.

REAR PROJECTION

The ideal way to see the slides while painting is in a brightly lighted studio and on a large screen right next to the easel. This can be done through rear projection with little effort and expense. Ordinarily slides are viewed as a reflected image on a beaded screen which can only be seen in a darkened room. With rear projection the screen is like the ground glass viewing system of the camera. Instead of ground glass, however, tracing paper is used. Frosted acetate may be substituted for the tracing paper but this is an unnecessary expense. Do not use tracing vellum. It's too opaque.

A rear projection screen is simply tracing paper stretched across the frame. This can be canvas stretchers, a picture frame, or a simple frame of one by twos which is what I've done. The proportions should be 2 to 3 – mine is 20" X 30". Tracing paper should be stretched across the frame in the same manner as stretching a canvas. The tracing paper should be reasonably taut so that it presents a flat plane to assure sharpness.

The 35mm slide fits into a mount that's 2 inches square. Since the transparency itself is only 1" X 1 1/2" this permits projec-

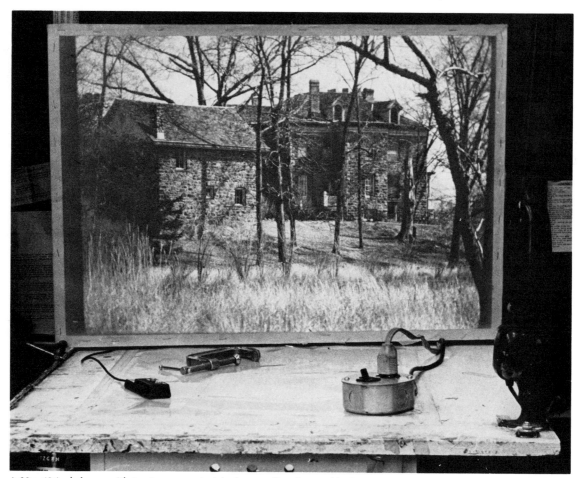

A 30 x 40 inch frame with tracing paper stretched across it makes an ideal rear projection screen. It's held in position with a C-clamp.

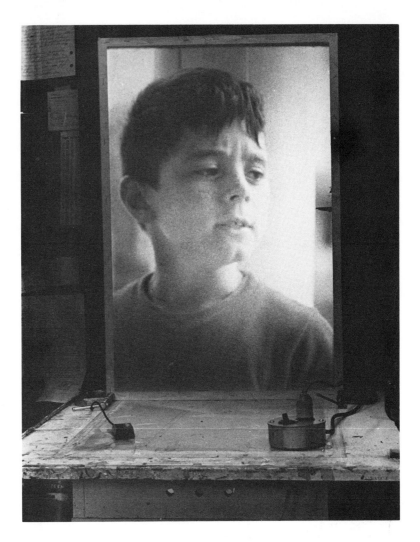

The same screen is turned for vertical slides. When the projector is plugged into a switch outlet in front of the screen, it can be turned on and off at will.

tion of horizontal and vertical images with the same projector but not so the screen. For vertical slides it must be made to stand on end, and on its side for the horizontal. I use a C-clamp to support the screen in either position, simply clamped to a corner of the base as needed. The flat screen can be stored easily.

Slightly behind my easel and to the left is a door leading into a small all-purpose room. When painting from slides the drawing table and screen are placed in front of this doorway. The image fills the 20″ X 30″ screen when the projector is placed approximately 8 feet away. By moving the projector further back, bigger enlargements can be made. It's not uncommon for me to include only a small portion of a transparency. Happily, there's no apparent loss of sharpness with the greater enlargements.

If there's no convenient doorway, rear projection works just as well in any room provided no extraneous light strikes the back of screen. It should be enough to just turn off the lamps, draw the curtains, and put out any ceiling lights behind the screen. However, if the light behind the screen cannot be controlled, a cardboard tunnel is the answer. Cut four pieces of corrugated cardboard, 24″ wide by slightly longer than the length of each side of the screen. Tape the four corners together so that there's an open rectangle. Place the screen just inside one of the open ends, and the tunnel is complete. Although it's not essential, the inside of the tunnel can be painted a flat black. With the ends taped, the tunnel should fold for storage.

Next to the easel and in front of the screen, place the remote control device and the switched extension cord. The remote control can be used to change slides without leaving your position at the easel. To prolong the life of the projector lamp, switch it off at the extension cord outlet when not needed.

This compact viewer can be folded up and requires little storage space, in spite of the reasonably large (8 inch square) viewing screen.

An improvised rear projection screen isn't the only answer. There are many excellent rear projection viewers on the market. None are cheap, and all are relatively small. There's one that does cost less than the others which has a reasonably large screen. It's made of plastic, and is about the size of a portable television set. In fact it does look much like a TV set except that there's an opening in the base into which the projector's image is beamed. With a mirror the image is reflected onto the screen.

The most compact viewer is the one pictured above. When not in use the screen folds down. The viewer, when closed, resembles an attache case with the handle on the end. Because it can be carried easily, it's admirably suited for presentations. It's small -- 10″ wide, 13 1/2 ″ long and 5″ deep

with an 8″ square viewing screen -- and needs no other accessories. When the top is raised, the screen, which is hinged, hooks onto a bracket mounted onto the underside of the lid. The angle formed by the screen and projector base is ideally suited for viewing. Like the other viewer, it works on the principle of rear projection. Slides are held in a tray and manually operated. The tray holds 36 slides. Its small 75-watt projection lamp needs no fan to keep it cool.

Since long projection times shorten the life of lamp, here, too, it's a good idea to control it with the switched extension cord even though the switch on the viewer is within easy reach. If you're like me, your hands are covered with paint. It's better to get the paint on the extension cord than on the viewer.

The 120mm transparency is quite a bit larger than the 35mm. Because of the scarcity of reasonably priced 120 automatic projectors you might consider cutting down the large transparency to super-slide size. It would fit into a mount 2″ square, the same size as the 35mm, but picture area would be considerably bigger. The cropping for the super-slide should start when taking the picture. Allow for 1/4″ to be cut off all the way around. When ordering the processing, specify that the processed film is to be left unmounted.

Improvise a light box by taking a small pane of glass, about 8″ X 10″, to which is taped a sheet of tracing paper. Form a bridge with the glass and some books. Underneath the glass place a lamp. The small high-intensity lamps are ideally suited for this. On the tracing paper draw a 1 1/2″ square. This is the size of your super-slide. The tracing paper will diffuse the light so that the slide can be seen clearly without strain.

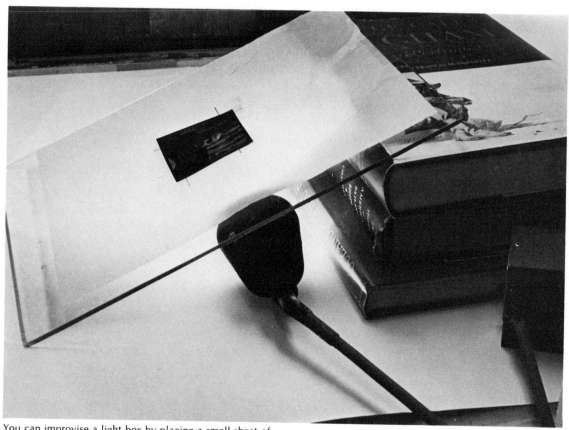

You can improvise a light box by placing a small sheet of glass (about 8 x 10 inches) against a stack of books. Cover with tracing paper and put a lamp under the glass.

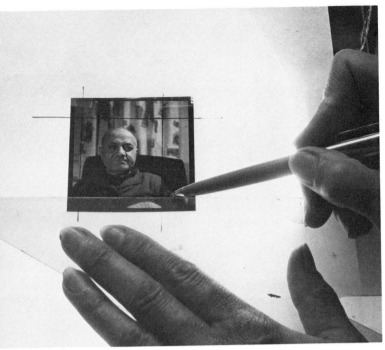

Draw a 1 1/2 inch square on tracing paper. Slide the transparency over the square until the desired framing is achieved. Score the slide with a ball point pen.

Cut along the scored lines with a razor blade or pair of scissors.

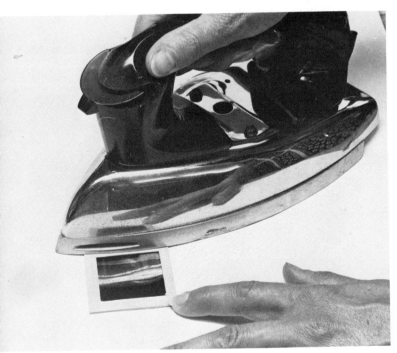

Place the film in a slide mount and seal the edges by passing a warm iron over them. Be careful to avoid touching the film with the iron.

Select the slide which is intended for the smaller size. Shift it over the square outline drawn on the tracing paper until the desired framing is achieved. Tape down the slide by its edges. With a ball point pen and a straight edge score the slide. Make sure at this time that it's the desired cropping because once scored the slide must be cut on these lines.

Lift the slide from the tracing paper by pulling up the tape. Cut along the scored lines with scissors. The slide is now ready to be mounted.

After the slide has been cut, grip it only at the edges to avoid finger marking it. Slip it carefully into the hinged slide mount. Close the mount. To keep the slide in place hold down a corner of the mount with your finger. Seal the mount shut by running a warm iron along its edges. Because the transparency can be damaged by the heat be sure to keep the iron from touching it. When held next to the 35mm slide it really does look super-size.

CHAPTER 10
TAKING THE PICTURES

When taking photographs, the primary concerns are exposure and sharpness. Exposure and what it constitutes can be frightening when the artist is first confronted with a modern 35mm or twin-lens reflex camera. The photos on pages 89 and 91 show clearly where the exposure controls are located on both camera types. The next six pages will be devoted to describing how exposure works in the camera, how to determine the exposure and how to select the right combinations which will produce optimum exposure and maximum sharpness. Sharpness, which is really focusing the camera, is described on pages 84 and 85.

Before moving on with exposure I must return briefly to the film. Earlier I alluded to film speeds. This has a great bearing on exposure. The speed of the film is related to how quickly the emulsion reacts to light. It takes longer for the image to be recorded on a slow film, so it's given a lower speed number, referred to as ASA (American Standards Association). A fast film has a higher ASA number. It follows then, that

Kodachrome at ASA 25 is a much slower film than GAF ASA 500. Both are color transparency films.

The slower films offer a sharper, more intense color image. The reason lies in the grain structure of the emulsion, and in the contrast. The grain is very fine in the slow films. They have little exposure latitude which means that if the exposure is for the light areas not much information will be recorded in the shadows -- a short gray scale. Faster films with greater latitude have a coarser grain structure which makes them less sharp, less brilliant in color, but with a longer gray scale that offers greater shadow information.

When projected, the slower films retain their sharpness and brilliant color while offering enough information in the shadow areas to paint from. You can see more in the shadow through rear projection than with the reflected image. The faster films are less sharp and grayer but only relatively so. A good rule of thumb is to use faster films in poor light and slow films for daylight.

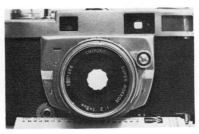
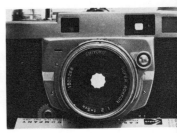

EXPOSURE AND HOW IT'S DETERMINED

Bundles of light traveling into the camera expose the film. These bundles can be either fat and short or thin and long. The diameter of the bundle is determined by the F stop or aperature in the diaphragm. Its length or duration is determined by the shutter speed.

Across the top of these two pages is a typical 50mm F 2 lens showing the stages of the diaphragm from the widest aperature to the smallest. The F number under each lens describes the diaphragm opening for that aperature. So that exact exposure control can be maintained, each smaller F stop lets in exactly half as much light as the next wider. We know that F 4, for example, will let in half as much light as F 2.8 and one fourth that of F 2.

Any 35mm or twin-lens reflex camera that you may buy will have exactly the same F stop numbers as are listed here. There may not be an F 2 or an F 22, the largest and smallest aperatures, because the lens in your camera will be either faster, F 1.9, or slower, F 3.5. Since the number F 3.5 falls between F 2.8 and F 4 we know that it must be only half a stop and would let in only one and one half the amount of light allowed by F 2.8.

Each shutter speed is almost exactly twice as fast as the one preceeding it. Here's the progression: 1 second, 1/2, 1/4, 1/8, 1/15, 1/30, 1/60, 1/125, 1/250, 1/500, 1/1000. When shutter speed and diaphragm openings are combined they produce exposure. Interestingly enough the correct exposure is not just a single combination but can be many. The situation will almost always dictate the combination. Here's an example of a series of combinations which produce a single ex-

posure: F 11 at 1/60; F 8 at 1/125; F 5.6 at 1/250; F 4 at 1/500; F 2.8 at 1/1000.

To understand this think of this bundle of light as a single drinking straw. It's long and thin at F 11 at 1/60. If it's cut in half it's twice as thick but only half as long, F 8 at 1/125. Cut in half again it's four times shorter, F 5.6, and four times faster, 1/250. It's eight times faster, 1/500, and only one eighth as long but·eight times as wide at F 4.

There's a definite reason for choosing a particular one from this series of combinations. An illustration might be in the use of Kodachrome 25 in bright sunlight. When reasonably close to a stationary subject and the need is for great depth of focus – see pages 102 and 103 – F 11 at 1/60 would be the logical choice. On the other hand if the subject were moving, F 5.6 at 1/250 might be better.

Light falling on or reflected from the subject can be measured accurately with a light meter. Pictured on the right is the light meter that I've had for the past fifteen years—the only light meter that I've ever owned. Known as the reflective type, this meter measures the light reflected from the subject. Most still camera meters are of this type. The other types, which record the light falling on the subject, are of the incidence variety and are primarily used for movies.

The reflective type must be used by holding the meter close to the subject, six to eight inches. With the incidence type the reading is also taken at the subject position, not aimed at the subject but at the light source. One advantage of the reflective type meter is that it offers a compromise exposure when the range of reflected lights

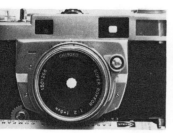
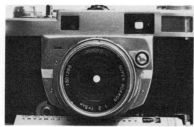

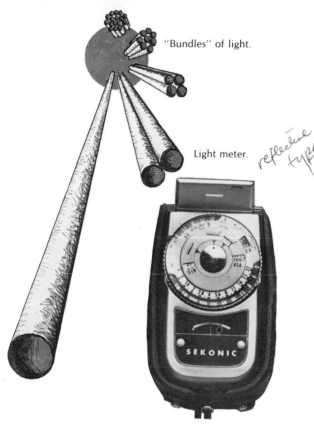

"Bundles" of light.

Light meter. *reflective type*

within a given frame are extreme, very light and very dark. The compromise, of course, is to take a reading from both the light and dark areas then set the dial to a point between the two.

Light meters are comparatively cheap and are a good investment. But there may be no need to purchase one. The automatic viewfinder cameras have their built-in metering system and nearly all the newer single-lens reflex cameras have them as well. My newest single-lens reflex, purchased used, was a terrific bargain because it had no built-in meter. You might consider that a used single-lens reflex camera plus a new light meter would cost considerably less than a new reflex with a built-in meter.

Both the hand-held meter and the built-ins accomplish the same purpose except that the built-ins are designed to be used from the camera position. Each type measures the light reflected from the subject, registered by a movable needle. With the built-in meter the needle is lined up with a center slot by turning the diaphragm ring on the lens barrel. On the hand-held type the large center wheel is turned until the large arrow is centered over the needle -- they're not aligned in the photo so that needle and arrow can be seen separately.

It's important that the film speed, ASA, be recorded on the meter before a reading is taken. Notice that in the ASA window the established speed is one notch above the 100 mark. This is ASA 125, the speed for professional Plus-X 120 film which was the film used to take the photo. If the arrow and needle were aligned it would indicate the following exposures: F22 at 1/2; F 16 at 1/4; F 11 at 1/8, etc. Because the camera was very close, great depth of focus was needed -- see next two pages. I chose F 16 at 1/4. Since the camera was mounted on a sturdy tripod there was no fear of motion blur.

For greater accuracy my meter measures light in three different ranges. When the slotted flap is closed, the meter registers only in brightly lit areas. For this situation the left hand arrow on the larger wheel is lined up with the dot on the inner wheel. In poor light the flap is raised, exposing the entire photoelectric cell, and the arrow is aligned as in the photo. A very large booster cell is swung out in very dim light and the arrow on the right is aligned with the center dot. By moving the arrows, the F stop scale changes in relation to shutter speeds to accomodate the different light levels.

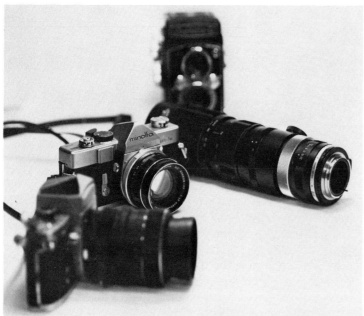

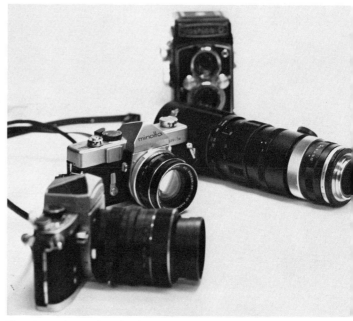

The above photos describe those areas in focus at different apertures. Note that the smaller the F-stop the sharper everything is from front to back.

DEPTH OF FOCUS

When a lens is focused at a specific distance, not only is everything in that plane sharp but a small area in front and twice that area behind is also in focus. This is depth of focus. There are three factors which affect it: camera to subject distance, F stop, and focal length of the lens.

As the camera and subject draw nearer, the shallower becomes the depth of focus. At distances beyond fifteen feet it is so deep for a normal lens that nearly everything appears to be in focus. Most fixed focus cameras are set at this distance. Long focal length lenses, telephotos, must be focused well beyond this distance, some of the longer ones nearly to infinity. We're primarily concerned, then, with normal lenses and subjects which are fifteen feet and closer.

The still life photos of telephoto lens and cameras above clearly describe the effect that the F stop has on the depth of focus, but I must first explain the set-up. A view camera was used. This type, as I explained earlier, uses ground glass focusing. Ordinarily the camera accepts film which is 4" X 5". For these photos I used a roll film

back adapter which advances film much like the semiautomatic twin-lens reflex does. The film was 120 professional Plus-X pan with a film speed of ASA 125. More importantly, the camera is equipped with a 135mm lens, which is normal for the larger film but a short telephoto for the 120 size.

A sheet of white bristol was laid on my drawing table. The only light source, except for the regular studio lights, was a floating-arm fluorescent lamp attached to the table.

The camera was focused on the lens of the middle SLR (single lens reflex camera). This point was selected because it was approximately 1/3 into the composition. Remember that the depth of focus includes 1/3 in front of the point of focus and 2/3 behind. At F 4 and 1/30 the middle SLR and only a portion of the zoom lens are in focus. With the camera at F 8 and 1/8 most of the zoom lens is now in focus while the front SLR is a bit sharper. We find that at F 16 and 1/2 nearly everything is sharp but not quite as good as at F 22 and 1 second where everything is sharp.

The shutter speeds are just a bit slower for these pictures than for the photo of the

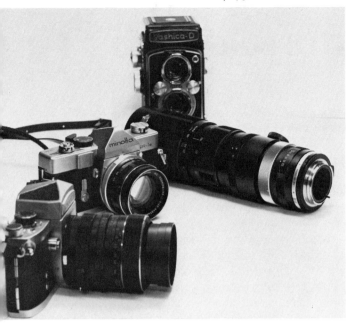

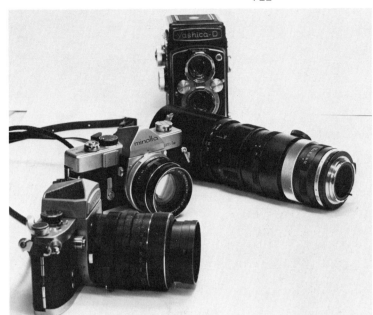

light meter on page 101. The reason is that the lamp had to be raised higher to establish an even distribution of light over the entire still life.

Whereas still lifes require that the diaphragm be stopped down to at least F 16, portraits do not. Usually F 8 will produce sufficient depth of focus to include the entire face, provided that the point of focus is the eyes. They are located slightly forward of the 1/3 point on the entire head but do allow for a shallower depth of focus which includes the tip of the nose and the ears. Whether the back of the head is critically sharp or not is only of relative importance, which brings us to selective focus.

As an artist you may prefer not to have everything sharp. The single lens reflex is ideally suited for this. There's a preview button on the side of the lens which, when pushed, will cause the diaphragm to close down to the preselected F stop. Although the image will be much darker because of the light loss, the areas of critical focus are readily discernible.

Another area where depth of focus is a critical factor is in extreme close-ups.

Remember that the center point of the lens where the diaphragm is located is at its closest point to the film plane when the camera is focused at infinity. It stands to reason then, that the further away from the film plane this center point is moved, the closer the focusing distance. With the single-lens reflex this point can be extended beyond the norm by placing extension tubes or bellows between the lens and camera. Through such a device objects as small as tiny insects can be made to fill the frame. There is a problem with exposure though. The greater the distance from the diaphragm to film plane the longer the exposure. It takes a bit of math to solve the problem with a separate light meter but with the built-in variety the reading is always right, because the meter measures the light as it would strike the film.

The optimum opening for the artist's needs would have to be F 8 since a lens is sharpest at this point, three F stops from its maximum aperature. There's sufficient depth of focus for most needs, and in daylight the accompanying shutter speed of 1/125 seconds avoids motion blur.

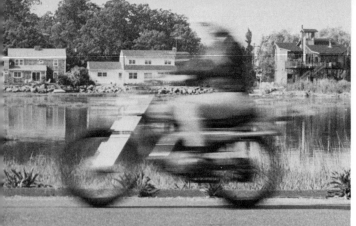

1/60

STOPPING ACTION

Although F 8 at 1/125 may be the optimum combination for the artist, the speed of the film, subject motion and the lighting conditions may dictate otherwise. Since the speed of the film has been discussed, we can cover subject motion next. When the action of the subject is directly toward or away from the camera position, you don't have to make an adjustment for its speed. Focus on an area through which the subject must pass, then at that point take the picture. If at all possible the focusing point should present a frame filling image. The actual focusing distance is not critical, because at F 8 there should be sufficient depth of focus to assure a sharp image.

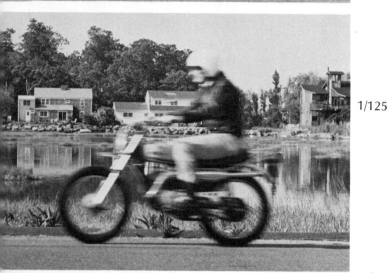

1/125

The situation changes when the subject approaches or retreats from the camera position at an angle. A fast shutter is required then. Although it need not be as fast as subject motion which occurs at right angles to the camera position, I accept it as such. I have prepared a demonstration to answer the question of relating shutter speed to the action. With a camera firmly mounted on a tripod and focused on a spot in the roadway a motorcycle was driven past at a fixed speed of twenty miles per hour. As you can see, the depth of focus at this distance is so great that there is no apparent loss of sharpness in the background even though the widest aperature is F 4.

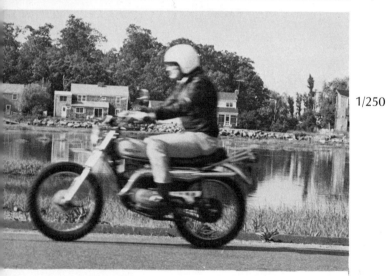

1/250

At 1/60 the motorcycle is a mere blur. The vehicle and driver are more distinguishable at 1/125 but not at all sharp. Even at 1/250 the subject isn't sharp. It isn't until a shutter speed of 1/1000 is used that the subject is sufficiently sharp to see it clearly. Unfortunately, there is no illusion of motion. In the stop action photos of the jumping horses in Chapter 3 the illusion of motion is achieved by the attitudes of the animals.

There is a solution for gaining sharp images of moving objects like motorcycles and cars which also retains the illusion of motion. It's called panning. For this

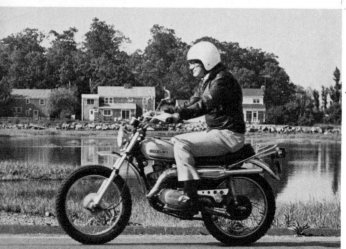

1/1000

Stopping action requires a fast shutter. Note that the cycle and rider are sharp only at 1/1000 second.

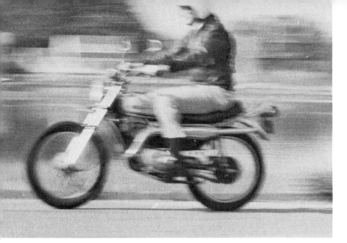

1/30

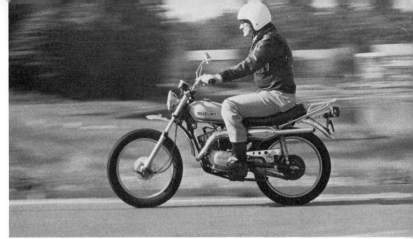

1/60 The sharp image can be achieved by panning (following the action with the camera). It also gives a greater illusion of speed with the background blurred.

demonstration the camera remained at the same spot with the motorcycle traveling at the same rate of twenty miles per hour. Instead of the camera being fixed it was permitted to swing along the path of the motorcycle. In other words, the rate of swing to the camera was equal to the speed of the motorcycle. Because the motion of the motorcycle was equal to the rate of swing the motorcycle could be considered stationary. Only the background was in motion. A slow shutter speed could be used. At 1/30 it was too difficult to coordinate both camera and motorcycle, with a resulting blur. When the shutter speed was advanced to 1/60, however, the results were even better than those taken with the stationary camera at 1/1000.

Camera motion is another blur-causing culprit. Many people claim a considerable skill for hand-holding the camera at slow shutter speeds. My feeling is that the missed shot may not be worth the bravado. The slowest shutter speed I prefer to use without support is 1/125 and even then I hold my breath when I squeeze the shutter. When a 35mm transparency is projected to 20" X 30" on a rear projection screen, even the tiniest motion will have blurred the image enough to cause annoyance. In addition to holding my breath the squeezing motion is a double action process. When the camera is in the horizontal position, I hold the camera with the index finger on the shutter release with the thumb at the base of the camera. Pressure is applied with index finger and thumb simultaneously until the shutter is released. In the vertical position the finger and thumb are reversed.

To keep the camera steady in the horizontal position, the shutter is released by pressing the shutter release button with the index finger while producing an equal amount of pressure with the thumb, which is placed on the bottom of the camera.

For the vertical position, the thumb and index finger positions are reversed. Holding your breath while releasing the shutter is an added precaution.

105

PRESENTING THE CAMERA

You may have begun to think that the variable focus and exposure camera presents too many complications for your interests. As I mentioned earlier the Instamatic type cameras are equipped with a fixed aperature of approximately F 8 focused at a distance of approximately 15 feet with a shutter speed in the neighborhood of 1/100. There is no reason why that procedure of fixed controls can't be applied with a better camera.

A few years ago my uncle and I planned for a cross country, picture-taking jaunt. After a rather prolonged search for a moderately priced viewfinder-rangefinder 35mm camera, there was little time left to practice. I preset the camera at F 8 and 1/100, set the focus at infinity and instructed him to change only the distance scale to 10 feet for people. Six weeks and ten rolls later I discovered that the slides were of very good quality, but more importantly, after the third roll my uncle began to make adjustments in exposure and had begun to use the rangefinder to focus. Of the 360 photos taken, many were portraits of friends and relatives along with interesting close-ups of flowers. Because my uncle had not included a light meter among his purchases, he resorted to the exposure guide which accompanied the film. Although he's taking excellent photos, he still has not gotten around to buying a light meter.

To carry the idea a step further I did the same thing for my eleven year old daughter, Suzanne. Before she left on a school trip, I loaned her my viewfinder 35mm and preset it to F 11 at 1/250 with the same instructions concerning people and scenes that I gave to my uncle. The film used was Plus-X pan, a black-and-white film. Of the twenty-four pictures taken, twelve are reproduced here. The remaining twelve are as good but lack the interest of these.

NOTE TAKING

For me the camera is an information gathering instrument with which I can gain many impressions in a short period of time. While walking through an area, whether familiar or unfamiliar, I'm constantly on the watch for interesting objects or relationship of objects to record. As each of these is recorded, it may or may not present painting possibilities. Perhaps, because of this, I try always to establish a unifying theme. Most often it's the light and shadow pattern of the first photo taken. I make note of it and try to repeat it throughout the session.

On an evening not long ago my wife and I strolled along the river bank. The purpose was to record objects lit by low angle sunlight so that they might be included in winter as well as summer paintings. As we walked toward the river I saw and recorded a fire hydrant. The sun was to my right. With each succeeding shot the sun was always to my right except for a couple of boats which were lit from my left. It's reproduced backwards here to conform with the others. Can you find it?

Nearing the end of our walk I discovered a bush which cast a shadow pattern of leaves across a second fire hydrant. Because of the single light source, any or all the objects can be put in the same painting, be it summer or winter.

Of course, the use of a single light source is not needed to augment the theme of a single subject. As in the case of the farm discussed in Chapter 1, the unity is established because it's of a single subject, where I recorded the whole plus its parts. However, it should be noted that the motorbikes and rock, covered in Chapter 5, worked together because the light source for both was the same.

With a light source from a single same direction, a variety of subjects can be related regardless of the actual locale.

The basic equipment for indoor shooting can consist of a ceramic light base with spring clamp, a number 2 3200K Photoflood and an extension cord with a switch.

The prospect of taking photographs indoors conjures up for many the image of bringing into the studio all the brilliance of a movie set crammed with expensive equipment. Nothing is further from the truth. With a good camera, photos taken inside can suggest the brilliance of the out-of-doors even though the light level is low. The answer lies in proper exposure and selective lighting. Although the aperature of the diaphragm will naturally be wider and the shutter speed slower, there's no reason why the photos should not be as good as those taken out-of-doors.

Unfortunately I have invested quite a bit of money in inexpensive reflector floodlights with switches built into the sockets. The reflectors worked well but the switches didn't, the heat caused them to malfunction. As a result, spare switches were kept on hand to replace any which failed during a shooting session. The reflector floods produce a rather concentrated light, causing harsh shadows. When these shadow areas were filled in with a second flood, additional conflicting shadows were cast by them. The answer was to diffuse one or both of the lights. An easier solution was

to simply remove the reflector. It also led to a solution for the burnt out switches...place the switch on the extension cord rather than on the lamp.

Pictured above is the extent of my lighting equipment, or half of it. There are two ceramic sockets with spring clamps purchased at the local hardware for less than three dollars apiece. For each light there's a heavy duty extension cord with a regular wall-type switched outlet on its end. These are multipurpose items because they're used in the home, workshop, and perform a variety of other photographic functions. The final items are two number 2 500-watt 3200K photofloods.

The K in the above description refers to the color temperature of the bulb. It burns at 3200 degrees Kelvin. All color film for indoor use is balanced to this temperature. Because this light is so far into the red range, the film is manufactured with additional cyan blue dye. Daylight film, on the other hand, is balanced to the white light of the sun, therefore, there's more red orange dye. When daylight film is used with artificial light, it has a predominantly red orange cast which I find in many cases

The electronic flash is small, lightweight, and puts out lots of light. An extension P-C cord permits you to move around with the camera while the light remains in a fixed position.

rather pleasant. Not so pleasant is tungsten, artificial light, film when exposed in daylight, with a bluish cast. The 3200 K bulb is a better choice than the normal photoflood because its life expectancy is four times greater, 24 hours as opposed to 6.

The electronic flash produces an excellent light for indoor use. Its white light is the same as that of the sun, so daylight film is used. The exposures are much like the out-of-doors with small diaphragm openings and a fantastic 1/1000 shutter speed. (When a camera is synchronized to an electronic flash the shutter speed dial is turned to the sync position, 1/60, then while the shutter is open the flash goes off. The duration of the flash becomes the effective shutter speed. This is usually 1/1000 but with some equipment it's even shorter, 1/2000.)

When used on the camera, the flash produces a flat light, red eyes and for the most part, unnatural looking pictures. Flash can be an effective light source, however, if it's taken off the camera and moved to one side. On the flash there's a short cable which is designed to plug into the X outlet on the camera. Since this cable is too short for remote use, you need an extension cord.

It's an inexpensive item. Brackets are availabe for attaching the flash to almost any object. I've purchased the camera type bracket which was attached to a strip of wood. The wood strip can be attached to almost anything with a C-clamp. There are flash brackets available with spring clamps.

Should you plan to purchase an electronic flash be sure that it can be used off the camera. Some electronic flashes, the "hot shoe" type, are designed to be used on the camera only. Some electronic flashes, not necessarily the expensive ones either, are capable of measuring the distance to the subject, within a limited range, and balance the light to a pre-selected F stop.

The electronic flash costs vary from very little to a great deal, depending on the output and function. The cheapest are equipped with replaceable dri-cell batteries. My first flash was of this type. I didn't like it because the dri-cells were just not dependable enough and corroded in the flash after prolonged periods of disuse. The rechargeable flash is a better buy. The savings over a period of years—I've had mine for six now—will far outweigh the small additional cost.

This is a typical lighting set-up for portrait shooting. The higher light on the right is slightly behind the model and gives highlights to the hair. The lower light on the left is the main light source.

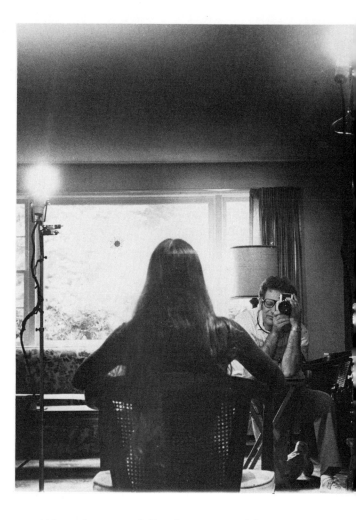

Two unreflected floods placed within six feet of the subject offer diffused light with no hot spots (glare) or black shadows. The walls, ceiling and everything else around act as reflectors which add a brilliance to the room not obtained with reflector floods. You should not be fooled by the apparent additional brilliance because there's actually less light falling on the subject. Whereas with two reflector floods the exposure for ASA 400 film would be F 11 at 1/60, it's F 8 at 1/30 with the unreflected floods.

Portraits and figure studies seem to be the principle reason for taking photos indoors. It seems logical, therefore, to concentrate my demonstration on the figure. The living room was used for a studio. Nothing special was done except to move in a chair for Tammy, my older daughter, to sit on and to set up both flood lights. These were placed on light stands but almost any support would have worked as well.

The principle light was raised about five feet from the floor, about four feet in front of Tammy and slightly to her left. It was just far enough left to produce a short descriptive shadow pattern on her right side. The second light was a foot higher and about two feet beind the model (lower photo). Because its main function is to highlight Tammy's hair, this light is actually closer than the principle one. I rather like the extra highlights on her forehead, cheek, and nose because there are no additional cast shadows and they bring an added sparkle to the face.

When the second flood was moved further behind Tammy by an additional two feet, the extra highlights were eliminated, although the light spilling over her right shoulder remained. This, too, I found an asset.

Since the optimum aperature is F 8 for sharpness and depth of focus I had no choice but to use it, even though it forced a shutter speed of only 1/30, which left no assurance that the results would be free of motion blur if hand held. But the camera had to be hand held to support my claim that only a minimum of extra equipment is needed for indoor shooting. Using a folding snack table for support, I formed a tripod with my two arms and torso. So certain am I of support and rigidity given by this stance that shutter speeds of 1/2 can be held with confidence.

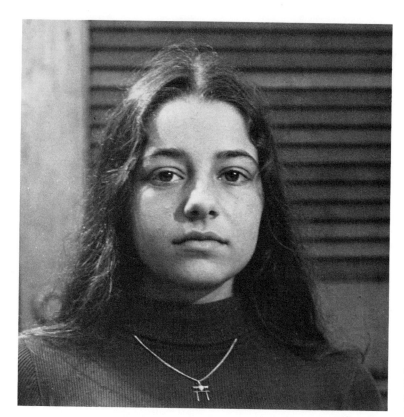

When the rear light is kept behind the subject, soft modelling of the features is achieved.

With the light a bit forward, the added light on the face produces small highlight areas which can accent the features.

Whereas the floodlights are placed close to the subject, the flash must be at least ten feet away to avoid hot spots and inky shadows. It should also be placed higher than the principle flood to produce highlights in the hair.

When the available light level is low it's difficult to focus on the subject because the flash supplies no light until the shutter is tripped. This also eliminates the opportunity to see the shadow pattern before the picture is taken. It's a good idea to clamp a floodlight next to the flash to facilitate focusing and to determine the light and shadow pattern. Turn off the flood before shooting.

With the flash at ten feet from the subject the diaphragm was set at F 11 and because the flash peaks at 1/1000, that was the effective shutter speed. The camera could be hand held with no fear of motion blur. The subject can even be in action and the fast shutter will freeze it.

When the photos on the next page are compared with those taken with the unreflected floods, they appear sharper. They appear so for two reasons: the light is more contrasty and I was closer to the subject. The camera position was not as fixed because, without a need for additional support, I was able to move about freely, which naturally led toward a tighter composition. Notice, though, that even with the greater degree of sharpness, the photos opposite do not give as much an illusion of solidity as those on page 113.

It's not uncommon to mix light sources. However, an admonition. Two equal light sources can produce confusing and unnatural effects of light and shadow that tend to break up the forms being photographed. It is better to place one light as the dominent one and to use any others as secondary or "reflected" lights to clarify detail that would be lost in shadow. With black-and-white film the intensity of the light source is the only regulator. When using color the question of color balance arises. The type of film used must be related to the principle light source. When flash is used, daylight film works best. This generally produces cool flesh tones. Warm

The electronic flash is positioned in the same way as the main light source in the previous flood-light situation. The extension cord allowed me to move at will just as with the photo-flood, but without the need for a tripod.

shadows will result with a tungsten fill-in. The contrast between the cool lights and warm shadows can be very pleasing. It's difficult to reverse the process by having floodlights for the principle source and flash fill because of the intensity of the flash. Even at twenty feet it would probably bring more light to the subject than the flood.

I must add that flesh color in a transparency is not always a true indicator of the subject's coloration. For this reason many portrait artists prefer black-and-white photos, then have the subject sit for a study or color adjustment. One of the considerable advantages of using photographs in portraiture is that in a short span of an hour thirty-six or more impressions of the subject can be recorded. This can give a helpful indication of personality along with the anatomy.

These two pictures appear sharper than those taken with the photo-floods, but because the light is more contrasty and I was closer to the subject.

To take pictures from the TV set, you must use a shutter speed of at least 1/30th of a second to get a complete picture.

Television offers a great variety of subject matter which can be of interest to the artist. You might find it useful to record from it. It's reasonable to assume that your television set and mine have equal brightness. I can, therefore, suggest an exposure that has worked for me. Although the human eye is not aware of it, the TV picture is scanned from top to bottom. To be sure that enough time is allowed for one complete scan, a shutter speed of 1/30 should be used. Should color film be used there is no assurance that the transparencies will be as good as the picture on your set. Again there's the problem of color balance. Because my attempts with color have been very limited, I can offer no suggestion about how you might succeed in getting better color. I have, however, gotten excellent results with black-and-white film. The exposure used most often with ASA 400 film is F 8 at 1/30. Although the camera was always on a tripod, you might hand hold it, using as a table for support or resting the camera on the table. With the camera on a tripod or on the table, it need be framed only once. As the show progresses, take the pictures that interest you most, without the need to look through the viewfinder.

When a camera is not equipped with a self-timer, a bulb cable release that allows you to get into the picture, even if the camera is 20 feet away, is a good investment.

Many, but not all, good cameras come equipped with a self-timer. This is a device, which when the shutter is tripped, actually delays its release for approximately ten seconds. Artists and photographers often use it to put themselves into the picture. But there's a better way...a bulb cable release. As an illustrator I often need a model, but when there's none available, I pose myself. With a self-timer there wasn't enough time to get set. The bulb cable solves that problem. With a slight pressure on the bulb, the shutter is released regardless of the cable length. The kit contains two cables, 30 feet and 20 feet long, which can be used together or separately. There is also an adapter to fit the flat head type shutter release. The regular tip is of the screw-in variety.

The biggest advantage of the bulb cable release is that it offers the artist a remote feature where it's to his advantage to be away from camera position. One of the most obvious situations that come to mind is for recording wild life. It has proven to be a very useful piece of equipment for me and very worth the nominal cost.

CHAPTER 11

PROCESSING THE FILM

Film developing and print making are basically simple; however, the variables plus the need for attention to detail make them involved processes. So I'll not cover them, because they're not part of the theme of this book which is concerned with the gathering of information with a camera for use in making drawings and paintings. There are a lot of good texts to be found on technical problems of developing and printing.

However, in view of the fact that black-and-white film is sometimes preferred by the artist, I'd be remiss were I not to include information on how to make black-and-white transparencies. These are simple to produce and practically no extra equipment is needed. The film can be processed at a laboratory which caters to the mass amateur market or to one for the professional photographer. Either will produce negatives of good quality. The difference is in the prints. The mass market labs will supply you with just a standard print for your format. There's a choice with the professional labs. The film can be processed without prints, with individual prints of any size you request, or with a contact sheet. The latter is a series of prints --same size as the negative -- on a single sheet of paper. Whichever system seems best for you is the one you should use.

Pictured on the right is all the equipment needed for the process. We'll start with what you probably already have: clamped ceramic light socket, and the switched extension cord. You'll need to buy a night-lite with a red bulb (10-watt), paper developer and fixer, both of which you can purchase in individual packets for one-time use, a small bottle of photo-flo, two print tongs, two 4'' by 5'' photo trays and two pieces of glass, 5'' by 7''. The film needed is Fine Grain Positive. It's 4'' by 5'', and packaged in boxes of 25 sheets.

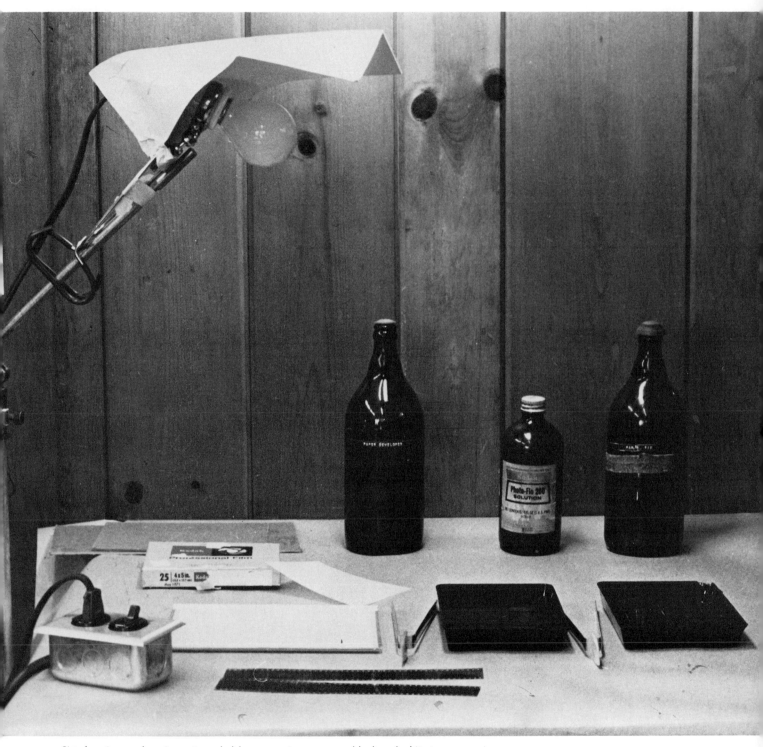

Simple set-up and equipment needed for processing your own black and white transparencies: shaded lamp with a 10-watt bulb, switch to control the lamp, box of 4 x 5 fine grain positive film, two pieces of glass, print tongs, two 4 x 5 photo trays, paper developer, fixer and Photo-flo.

With the two pieces of glass, make a printing frame by taping them together at one end. Cover one piece of glass, which you will consider the top, with a piece of tracing paper.

Mix the developer and fixer according to directions. If there is more of each than needed, the extra can be stored in tightly sealed brown bottles. I find the brown throw-away type with screw caps ideally suited for this. The paper developer and the fixer should be approximately the same temperature. Although the exact temperature is not critical, the most uniform results are achieved when the temperature is in the 68 to 70 degree range.

At night almost any room will function as a dark room. Although it must be dark, the red night-lite will produce sufficient illumination without fogging the film. Because the film is orthochromatic, insensitive to red, the light can be fairly close to the work area.

Make a shade for the lamp by folding a small piece of cardboard, taping it to the clamp as shown on page 119. Place this lamp with the 10-watt bulb approximately 24 inches above the printing frame.